Martin**Kline**

Martin Kline

ROMANTIC NATURE

Marshall N. Price

HUDSON HILLS PRESS New York and Manchester

Published on the occasion of the exhibition:

Martin Kline: Romantic Nature
March 17–June 17, 2012
New Britain Museum of American Art

M

NEW BRITAIN MUSEUM OF AMERICAN ART

56 Lexington Street
New Britain, Connecticut 06052–1412
Telephone: 860.229.0257
Fax: 860.229.3445
www.nbmaa.org

6

Published in association with Hudson Hills Press LLC
3556 Main Street, Manchester, Vermont 05254

Publisher and Executive Director: Leslie Pell van Breen
Founding Publisher: Paul Anbinder

Distributed in the United States, its territories and possessions,
and Canada by National Book Network, Inc. Distributed
outside North America by Antique Collectors' Club, Ltd.

Library of Congress Cataloging-in-Publication Data

Price, Marshall N.
 Martin Kline : romantic nature / Marshall N. Price.
 p. cm.
 Includes bibliographical references.
 ISBN 978-1-55595-348-5
 1. Kline, Martin, 1961---Exhibitions. I. Kline, Martin, 1961- II.
 Title. III. Title: Romantic nature.
 N6537.K574A4 2012
 709.2--dc23

 2011045094

Production and design by DFA/Design for Art LLC,
New York, www.designforart.com

Edited by Michael Dupree
Photography by Kevin Noble
Photography pages 10 & 160 by Ernesto Aparicio

Cover: detail of *Waking Dream for Kurosawa*, p. 102
Pages 2 & 3: detail of *Canary*, p. 116
Page 4: detail of *Bride of Frankenstein*, p. 101
Pages 26 & 27: detail of *Carbon Specimen*, p. 62
Page 109: detail of *Cast Painting*, p. 134
Page 160: detail of *Pandora's Box*, 2007, bronze (unique cast),
2¾ x 4½ x 4½ inches (7 x 11.4 x 11.4 cm)

Printed in an edition of 2000 copies

Printed and bound by
Arti Grafiche Amilcare Pizzi, s.p.a., Italy

Contents

DOUGLAS K.S. HYLAND
Director, New Britain Museum of American Art

The New Britain Museum of American Art is very pleased to mount the first major retrospective of the art of Martin Kline. For the last twenty-five years, Martin has explored in his drawings, paintings, and sculptures, a wide variety of reactions to the natural world. His large, colorful encaustic three-dimensional paintings are included in important American and European museums and collections, including the Albertina, the Brooklyn Museum, the Cleveland Museum of Art, the Fogg Museum, and the High Museum of Art. Over the years, Martin has traveled extensively and his works have been inspired by Asian culture as well as by many other diverse historical and contemporary influences. The selection of works in this exhibition was chosen by Martin and comes primarily from his holdings.

Because his work is lyrically abstract, critics and art historians have commented consistently on the romantic sensibilities Martin's paintings and sculptures evoke. He blends aspects of the beautiful with the sublime. His vision boasts the remarkable qualities of originality and consistency so that all of his works have a distinctive cohesive quality yet each explores a different theme and is the result of different influences. I am particularly drawn to his sensuous bas-reliefs with provocative titles that conjure up English literature and philosophy. Almost all have an organic quality which tethers them to the tradition of landscape painting. But, instead of a panoramic display, Kline concentrates on a slice of nature magnified and thus examined intensely. His beguiling and seductive creations engage us aesthetically but also intellectually because of the questions they evoke with regards to man's role with nature.

Over many years Christo and the late Jeanne-Claude have been consistent ben-efactors of the New Britain Museum and I owe them yet another debt of gratitude as it was after the funeral of Jeanne-Claude at The Metropolitan Museum of Art in 2010 that my attention was drawn to the stunning encaustic painting *Nest* (2000) hanging in the Met's contemporary galleries. My interest in Martin's work was piqued immediately and I then concentrated my efforts on visiting his studio in Rhinebeck, New York, where I was able to admire an overwhelming abundance of his creations dating from the 1980s to the present.

Most of all, I want to thank Martin for so enthusiastically embracing this project. At every step in this process he has provided thoughtful guidance and unstinting cooperation. On behalf of the entire staff I want to express our admiration for both his work and for him as a person. Well into our plans, I was heartened by his gift of *Empoisonner* (2001 and 2007) to the permanent collection of the Museum. The large, brilliantly colored encaustic will inspire and delight our visitors for generations to come. Both this work of art and the excellent catalogue will live on long after the exhibition is only a very pleasant memory.

8

I commend Marshall N. Price, Curator of Modern and Contemporary Art, at the National Academy Museum, for his compelling and important new essay for this publication. Also included are re-issued essays from previous catalogues on the artist for which we are most grateful to the authors who provide further insight into the work. Martin's photographer, Kevin Noble and his editor for this project, Michael Dupree are especially thanked for their vital roles. Those galleries and collectors who have supported Martin Kline's work and the lenders to the exhibition deserve special commendation.

As with all our endeavors, the Board of Trustees and the entire staff are due thanks. Those who played key roles in bringing the project to life include: Claudia Thesing and Melissa Nardiello, who facilitated the marketing of the exhibition; Linda Mare, Heather Whitehouse, and Laura Krah, who organized the related educational programming; John Urgo and Keith Gervase, who designed and installed the exhibition; Anna Rogulina, Alexander J. Noelle, and the Curatorial Interns, who worked with Martin on the creation of the labels, interpretive text, and organization of the exhibition; Melanie Carr Eveleth and Visitor Services, for welcoming our visitors and overseeing the myriad events related to this exhibition; Michael Smith, for assisting with the physical needs of the exhibition; and Tom Bell and Georgia Porteous, for organizing the financial components. As always, Marie Koller was an excellent editor and proofreader.

Operating support of the Museum is provided by the Greater Hartford Arts Council, the Connecticut Commission on Culture and Tourism, the American Savings Foundation, and the Community Foundation of Greater New Britain. Additional funding comes from the Sam and Janet Bailey Family Fund for Special Exhibitions. I must also acknowledge our upper level membership groups, the American Art Circle and the John Butler Talcott Society, as they annually contribute substantially to help underwrite our exhibition programs. The venerable New Britain company, Stanley Black & Decker, is owed an enormous debt for their generosity to the Museum.

As with every mid-career retrospective, this exhibition represents a significant milestone in Martin Kline's career. With such a rich and varied body of artworks already in evidence, it is with keen anticipation that I look forward to his further evolution and to the next twenty-five years which I am confident will be equally fecund and remarkable.

Natural Phenomenon

MARSHALL N. PRICE

Martin Kline is an alchemist. His work fuses various formal elements, cultural sensibilities, conceptual practices, artistic techniques, and the differing notions of the natural and constructed worlds in a way that articulates intrinsic teleological and existential concerns. Over the course of the last twenty-five years, Kline has created an extensive oeuvre beginning with his earliest drawings and watercolors in the middle 1980s and continuing through his most recent encaustic paintings and cast-metal sculptures.

While he has embraced a range of artistic methods—often with drawing at its root—he began working with the ancient method of encaustic painting about fifteen years ago, motivated by the desire to expand his practice. Among the oldest of painting techniques, this process involves combining wax with colored pigments. Essentially dormant for much of the modern era, encaustic painting was revived in the post-war period beginning in the 1950s, and reinvigorated by such artists as Jasper Johns, Brice Marden, and Lynda Benglis.[1] Kline has triumphed in adopting and adapting the encaustic process, creating a highly nuanced style of abstraction. He continues to draw with regularity and has also taken the logical leap from creating densely layered surfaces to sculpture, but his encaustic paintings remain at the heart of his work.

Well versed in contemporary art and art history, Kline's development as an artist has nevertheless taken a singularly autonomous trajectory. This independent path has enabled him to create an extensive body of work that, while indebted to some degree to his predecessors, is itself a conflation of practices and in turn an expansion of the language and tradition of painting. Kline's playful references to other artists and their creations are not literal but historical touchstones for him to ruminate and combine the serious, humorous, and ironic with his own distinctive and inventive use of wax. Martin Kline's approach is inherently dialectical, crossing boundaries of different media, combining seemingly opposed Eastern and Western cultural sensibilities, and eliciting Romantic, pre-Darwinian notions of nature while also alluding to knowledge drawn from modern science. Imbued with many references to the natural world, his drawings, paintings, and sculpture are nevertheless non-narrative, at least in a conventional sense, and they raise larger philosophical questions about humankind's interaction with, and adaptation of, nature. The artist's beguiling "growths," "blooms," and "accretions" are abstracted, intrinsically seductive and

OPPOSITE PAGE
Martin Kline studio, sculpture details

[1] There has been only one significant survey exhibition of contemporary encaustic painting. See, Gail Stavitsky, *Waxing Poetic: Encaustic Art in America*. Exh. cat. (Montclair, NJ: The Montclair Museum of Art, 1999), 24 et passim. Most contemporary artists who have worked in encaustic have cited the Egyptian Fayum portraits as inspiration and a point of departure. Unaware of the Fayum portraits at the time he started to work in encaustic, Kline came to the medium only after working for years almost exclusively in drawing.

contemplative interpretations of the natural world that articulate humanity's elaborate interconnectedness with it, while at the same time imparting a prescient admonition of the increasingly common and deleterious endeavors in man's wish to improve and exploit nature. The exhibition *Romantic Nature* presents the broad range of issues and approaches contained within Kline's works that make up the artist's captivating natural phenomena.

Early Biography

Martin Kline was born and reared in a large family in Norwalk, Ohio, geographically centered between the Cleveland Museum of Art and the Toledo Museum of Art. Visits to these two great museums and to the nearby Oberlin Museum had a great impact on him and he was encouraged to pursue his artistic interests. Kline put himself through college by enlisting in the Army National Guard. He attended Ohio University where he had a double major in studio art and art history, culminating with his BFA in 1983. The studio art curriculum followed a conventional course of drawing, printmaking, and sculpture. In his art history studies Kline took a particular interest in the Northern and Italian Renaissance and intentionally had very little exposure to contemporary art.

In 1983, at the end of his college studies and as part of the curriculum, Kline visited Italy with a group of classmates and art history professors. This first voyage to Europe had a profound effect. Having studied Renaissance masterpieces in the classroom, he was now able to see these works in person for the first time. Visiting Florence and Rome, he witnessed directly the masterpieces by many of the greatest painters and sculptors of the past. While Kline appreciated the subject matter and the emotional content in Renaissance paintings, he was particularly attracted to "...the detail and craft involved in works that were so highly rendered and polished. That appealed to me and I recognized these were elements that I wanted in my own work...the trip was an overwhelming experience."[2]

Following his graduation from Ohio University in 1983, Kline moved to Portland, Oregon. He worked part-time as a museum guard at the Portland Art Museum and taught a drawing class in colored pencil, his sole teaching experience. He was struck by the dramatic natural landscape of the Northwest region and quickly came to appreciate its native resources and vistas including Mount Hood and the Cascade Mountain Range, and the coastlines, rivers, and national parks in Oregon and neighboring Washington. Kline's employment at the Portland Art Museum put him in close proximity to a wide range of artistic treasures. For some artists, working as a museum guard is almost a rite of passage and many from earlier generations have worked in this capacity including Robert Mangold, Robert Ryman (both of whom have also worked in encaustic), and Sol LeWitt, all of whom worked at the Museum of Modern Art in New York. For Kline, spending extended hours in the presence of the museum's Asian, Northwest Coast Indian, and Cameroon collections, as well as the museum's holdings of American and European art, helped sharpen his eye and mind. As the artist reveals, "My time as a museum guard was my second education. Things in the permanent collection became old friends, and traveling exhibitions exposed me to different kinds of art like the California realists and Magdalena Abakanowicz. These changing shows were eye-openers."[3] Working at the museum,

2 Martin Kline, interview with the author, March 27, 2011.

3 Martin Kline, interview with the author, May 8, 2011.

Fig. 1
Narcissus, 1995
Ink on paper
30 × 22¼ inches
(76.2 × 56.5 cm)

Kline began to realize the value of looking at something over an extended period of time and the ongoing reward of getting to know a work of art intimately.

It was also in Portland that Kline was exposed for the first time to Asian culture. Not only did he see the wonderful collections of Japanese, Chinese, and Korean art that reside in that city, but he also enrolled in a Japanese art and literature class. He visited the renowned Portland Japanese Garden and became intrigued with the controlled aesthetic of its highly cultivated landscape. Kline's artistic output at the time continued along the lines of his college interests: representational compositions in elaborately detailed colored pencil as well as ink line-drawings of flowers and plants. By 1986, Kline had moved to New York, arguably the capital of the art world, intent on developing his art. It was there that within a few years his work would begin to change and move decidedly away from representation.

From Portland to New York

The early 1990s was an explosive period for Kline, who executed several series of drawings in which subject matter and form were gradually stylized and reduced. These series ranged from detailed colored pencil line-drawings on colored paper, to humorous charcoal figures, to brush and ink drawings of plants and blossoms. During this time, Kline developed an appreciation for 18th- and 19th-century drawings, which he started collecting in a modest way. The sensibility of these Old Master drawings was notably manifested in a body of sepia-saturated drawings, which set the tone for his later work. *Narcissus* (fig. 1) reveals a central abstract form of

14

Fig. 2
American Painting (II), 1996
pencil and encaustic on gesso
on linen
60 × 40 × 1¾ inches
(152.4 × 101.6 × 4.4 cm)

tangled ribbon that floats over a ground of swirling areas of varying density. This entanglement, something of a metaphorical Gordian knot, was cut by his swift development of a series of highly chromatic *Yucca* watercolor drawings, which Kline first exhibited in 1994.

Yucca (# 18) (p. 28) and *Emblem* (p. 29) both demonstrate the delicacy and intricacy of Kline's touch with the watercolor medium. At the time, drawing was the foundation of the artist's practice and these works retained a skillful, subtle touch of the Old Master hand, leading renowned curator Henry Geldzahler to refer to them as "Mannerist paper paintings."[4] However, Geldzahler erroneously ascribed the source of these watercolors to Charles Demuth's flower watercolor paintings. While they certainly share an affinity with the Stieglitz Circle painter's work through their inherent intimacy, delicacy of touch, and chromatic variation, for Kline they are highly personal works that evolved out of his burgeoning parallel interest in the natural world. Geldzahler's citation however, led Kline to explore Demuth's work and take away from it a greater sense of personal meaning, which he used in his later work. Referring to Demuth's famed painting *My Egypt*, Kline states "Demuth never traveled to Egypt. But you can travel to a place, literally or figuratively. And when you then make a work of art, it becomes *your* Egypt."[5]

The *Yucca* paintings began to take on an entirely different form in a series of transitional works beginning with a group of colorful grid-based watercolors. Works such as *Grid (Tapestry)* (p. 31) and *Ode to the Grid (#1)* (p. 32) incorporate a pattern-like systemic approach filled with circles and arabesque shapes, at which Kline arrived by way of the gradual reduction of the yucca blossoms. These works form

4 Henry Geldzahler, *Martin Kline: Yuccas*. Exh. cat. (New York: Stephen Mazoh, 1994), n.p.

5 Martin Kline, interview with the author, May 8, 2011.

the genesis of the important role the emergent grid would play within Kline's work. "A patch of grass, a forest, is a grid," Kline has said.[6] Subsequent series include obsessive and nuanced graphite drawings such as *Once Upon a Cloud* (p. 34), black oilstick drawings, as in *Labyrinth* (p. 35), ink wash on mylar works as in *Liquid Grid IV* (p. 36), and animated chromatic bursts of richly saturated colored inks in works such as *Tempest* (p. 37), all predecessors of Kline's foray into encaustic painting.

The transition to working in encaustic was, for Kline, a deliberate move to expand beyond working on paper.[7] In the mid-1990s he spent two years working in black and white encaustic before incorporating color into his painting. These early encaustic works, such as *American Painting (II)* (fig. 2), incorporate a grid format and suggest an indebtedness to some of the iconic works of Jasper Johns. It would not be unreasonable to say that nearly every contemporary artist working in encaustic owes a debt to Johns. However, rather than simply ascribing them solely as homages to Johns, these paintings may be understood as speaking to a specific American sensibility. The simplicity of juxtaposing black and white, and the distressed effect of the white ground bleeding through black, recall folk art objects such as game boards, shop signs, or as the artist has noted, the long tradition of American quilting.[8] These works break free from the modernist trope of the grid by their inherent irregularities—clearly these have been created by hand and even have the weathered look associated with extended exposure to the elements.

These black and white paintings, as in nearly all of Kline's work, have a strong associative dimension to them. They have the ability to collect, recount, and sometimes even memorialize. In this sense they are narrative, but not in the familiar manner of figure-based representation. Instead their iconography resides within a language of evocative abstraction. Many people have written of Kline's work within the context of Minimalism. Certainly his grid-based works and monochrome encaustic paintings could suggest an adherence to some sort of Minimalist doctrine, but this is an essentializing and narrow reading of the work. In fact, by its very materials-based nature, its variety—in detailed works of complex chromatic layering —and the pronounced touch of the artist's hand, these paintings and sculpture address a greater range of issues with a vocabulary far beyond that found in the cool reserve of Minimalism's aesthetic and sensibility. On one hand, Kline's forms breathe, grow, multiply, and reproduce; they seem to be alive and are generative, constantly moving. On the other, they are calm and contemplative, evoking a frozen moment in the life of a growing organism. Some of his work, in particular those including natural forms such as tree branches or stumps, have a mycological dimension to them that evoke a propagating fungal colony. In many ways, Kline's oeuvre is much closer to the process-based work that followed Minimalism in the late 1960s that included the exploration of new materials by painters and sculptors such as latex, lead, crude oil, and indeed wax. The touch of the artist's hand not only returned in these works, but for many, ultimately became the very locus of their practices.

Encaustic

The earliest group of encaustics to incorporate color included *Epiphany* (p. 39), and as indicated by its title, it was a harbinger of things to come. Unlike the dialectical relationship of black and white divisions found in *Black and White Diptych* (p. 40),

6 Martin Kline, email correspondence with the author, July 7, 2011.

7 Martin Kline, interview with the author, March 27, 2011.

8 Martin Kline, email correspondence with the author, April 23, 2011.

OPPOSITE PAGE
Fig. 3
Nest, 2000
encaustic on panel
51⅞ x 42 x 2⅞ inches
(131.4 x 106.7 x 7.3 cm)
The Metropolitan Museum of Art
Anonymous Gift, 2000 (200.642.1)

also from this period, *Epiphany*'s conflation of a figure-ground relationship allows it to reside within an elongated moment of temporal transition. A number of writers have focused on the temporal dimension in Kline's work. Insightfully articulated by poet and art critic Carter Ratcliff, this phenomenon is characterized as a formal interpretation, noting that: "Kline's truths appear *through* time or, one might say, in the course of a long embrace of temporality. His truths are not eternal but contingent and his works fascinate—literally—because they make the contingencies of his process so explicit. Their surfaces attract and hold the gaze the way an intricate drift of snow or a pattern of erosion sometimes does."[9]

Art historian Barbara Rose identified Kline's work as a type of "anti icon," and has acutely explained it within the context of a society in which instantaneousness has altered our perception of time and space and the notion of "real time" making space (real space) relative. "As an antidote to such instant assimilation of every kind of information, the anti icon slows down speed by involving the mind in the perception of a work of art that is gradually rather than instantaneously grasped."[10] For Kline, like Ad Reinhardt, seeing a painting is more than simply a perceptual exercise, but an experience. It was Reinhardt who "shifted the conception of seeing from an optical event to a phenomenological process and made durational time (of looking at a painting) a medium of ontological awareness."[11]

Some of these early encaustic paintings, such as *Dream of Betsy Ross* (p. 41) and *Daily News* (p. 46), are infused with the cultural attributes and notions of a nostalgic American optimism and thus echo earlier works such as *American Painting*. Kline admits that at the time he was questioning the notion of American painting. Developing his encaustic vocabulary at that time, Kline had a significant breakthrough in two small works that, while diminutive in size, are expansive in scale: *Charm* (p. 50) and *Culture* (p. 51). These were followed by *Waste Not* (p. 48) and *Scepter* (p. 54), one of the earliest branch sculptures where encaustic is directly applied to a three-dimensional found object. Kline had thus taken his first steps into the sculptural realm with these works, some of which carry an underlying cautionary missive.

Culture appears to grow before our very eyes as an expanding swarm of microscopic organisms at once beautiful but perhaps perilous. Seduction by beauty is a theme as old as history itself and here the metaphorical Siren's song is infused with the suggestion of a biological endeavor gone awry, an unfortunate but very real possibility with the preponderance of agro-industrial tinkering today. The artist took an opposite approach of sorts in subsequent works such as *Wound* (p. 54) in which he incorporated a tree branch, but now uses a natural fissure on the branch as the support for the application of encaustic. The result alludes to natural processes of coagulation and healing, its green color an allegory for the blood of living plants and chlorophyll. Kline's long-time involvement with the theme of nature gone astray is reflected in works such as *In the Lab* (p. 56), *Dream of Mary Shelley* (p. 55), *Dorian Gray* (p. 122), *Bride of Frankenstein* (p. 101), and the latest incarnation of *Painting Sculpture* (pp. 104 & 105), where the panel—its front, back, and sides—is covered with "growth." An attraction/repulsion tug of war exists in many of Kline's works, which could be perceived as ugly or beautiful (or both) depending on one's point of view.

Some of Kline's paintings, especially the first series of "bloom" paintings such as *Nest* (fig. 3), *Randazzo* (p. 57), *Phenomenon* (p. 60), and *Cosmos* (p. 59) are hypnotic, swirling yet meditative, distilled mandalas that each culminate in a central point.

9 Carter Ratcliff, *Truth Awakens as Fiction: The Art of Martin Kline.* Exh. cat. (New York: Jason McCoy, Inc., 2005), 6.

10 Barbara Rose, *Anti Icon.* Exh. cat. (West Palm Beach, FL: Eaton Fine Art, Inc., 2010), 13.

11 Alexandra Munroe, "Art of Perceptual Experience: Pure Abstraction and Ecstatic Minimalism" Alexandra Munroe, ed., *The Third Mind: American Artists Contemplate Asia, 1860–1989.* Exh. cat. (New York: Guggenheim Museum, 2009), 287.

While some, including *Randazzo* actually have a circular composition, others such as *Nest* simply allude to the circular through a subtle building-up of the encaustic surface in high-relief creating the suggestion of a spherical shape. These bloom forms, which have become some of the artist's most powerful imagery, recall similarly generative patterns in the works of avant-garde filmmaker James Whitney, who created early computer-generated animated films in the 1950s and 1960s that often had a psychedelic dimension. In particular, the round forms of many of Kline's kinetic, kaleidoscopic blooms bear a resemblance to Whitney's seminal film *Lapis* of 1965 (fig. 4). This is not to suggest that Kline was aware of or influenced directly by Whitney's films (he was not), but similar interests can sometimes be manifested in shared affinities that transcend generational and geographical distances. Though employing entirely different materials, both artists share an interest in perceptual phenomena, Eastern cultures, and a desire to create transcendent work. It does not take a great leap of imagination to envision Kline's encaustics springing into motion like Whitney's animations. The bloom is a shared cipher by the two artists and is redolent of the sacred Mandala. Writing perceptively about Kline's oilstick drawings, comparative literature scholar Marina van Zuylen's comments on Kline's work could equally be applied here to his early bloom paintings or Whitney's *Lapis*: "The world is about transformation. Cells multiply, spread, change, separate, and regroup. Nothing stops the perpetual motion that sustains and dissolves our universe."[12]

A Sculptural Dimension

As his surfaces became more and more built-up with layers of wax, Kline concluded that his paintings had simultaneously become sculptures. This prompted him to compound the issue by casting an actual painting in bronze using the lost wax technique to greater emphasize its sculptural aspect. This tactic expanded and populated the meaning and interaction of the disciplines of painting and sculpture. Casting a work in metal transforms the ephemeral into the permanent and each sculpture becomes a monument—a tribute to permanence, to nature in Kline's case, and the act of making art itself. Transformed, the new work retains its memory as a painting, especially because Kline's cast sculptures are all unique, direct casts. An early example of this is *Journal Entry* (p. 65), which, by its title, suggests the chronicling of transitory daily life, consecrated permanently in cast stainless steel with casting cup and sprues still attached. Kline has noted, "An artist's work is the diary of his life. Personal things start to come into the work and I want them to be there."[13] The language here, however, is not a written musing of day-to-day events, but an abstracted visual vocabulary that is nevertheless equally effective. A similar reminiscence is also found in *Van Gogh* (p. 66), a sculptural homage to the Dutch artist that appears as if it could reside in one of Van Gogh's paintings of his bedroom in Arles from the fall of 1889. Kline's chair is a three-slat, ladder-back, rush-seat commonly found in American households of the 19th century. With a dense application of encaustic that seems to bleed through the seat, it captures the provincial feeling of that Arles bedroom painted more than a century ago.

Kline is a consummate collector and his fascination with objects has informed his practice. He has a particular interest in modern Italian glass and ceramics, Neolithic stone tools, and Chinese scholars rocks and objects. Collecting has its roots in Kline's childhood in Ohio where he and his siblings spent hours in the

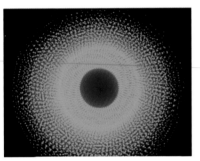

Fig. 4
JAMES WHITNEY
(American, b. Altadena, CA 1922-1982)
Lapis, 1965
16mm film, color, sound, 10 minutes
© Estate of John and James Whitney

12 Marina van Zuylen, "Martin Kline's Double Vision," *Martin Kline: Oilstick Paintings.* Exh. cat. (New York: Jason McCoy, Inc., 2004), n.p.

13 Martin Kline, interview with the author, May 8, 2011.

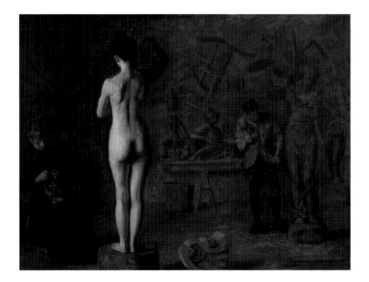

Fig. 5
THOMAS EAKINS
*William Rush Carving His Allegorical
Figure of the Schuylkill River,* 1908
oil on canvas
35 15/16 x 47 13/16 inches
(91.3 x 121.4 cm)
Brooklyn Museum, 39.461 Dick S. Ramsay Fund

19

woods searching for unusual stones, sticks, and other elements of nature. So, working with branches or stumps is, in a way, something of a return to the past.[14] Chinese scholars rocks or *Gongshi* hold a particular interest for him. *Gongshi* have played an important role in Chinese culture, providing inspiration, sources of meditation, microcosmic representations of nature, or even subject matter themselves for Chinese artists.[15] In ancient China, a canon of rock forms was quickly established and, in addition to the natural formations found within them, the rocks were often altered to enhance their beauty. Like the latter, Kline's scepters (pp. 54 & 69), the anatomical *Torso* (p. 74), and the objects on the scholars table (p. 67) in which the artist combines his encaustic technique with found objects, are a similar adaptation and enhancement of the natural world. The greatest formal difference between Kline's work and *Gongshi*—and most traditional sculpture—is that Kline's process is *additive*, one that occurs by building up an encaustic surface, while carving a scholars rock is a reductive process. Kline's works, both paintings and sculpture, with their heavily crevassed accretions, are often mistaken for being physically sculpted by hand rather than created with a brush.[16] It was at this time that Kline's sculptural investigations went beyond his scepters and scholar-related objects to include unique castings of his encaustic paintings.

Kline's choice of sculptural armature moves in a different direction in *Eakins (for Leo Steinberg)* (p. 75), which is not a natural tree branch but a scythe handle. Critic and scholar Leo Steinberg published an influential book of essays "Other Criteria" based on a lecture series he presented at the Museum of Modern Art in 1968.[17] Steinberg observes in the titular chapter that American artistic culture has a history of wanting to label art something other than what it is, in this case "Not Art But Work," a subject he expounds upon using both Eakins' beliefs and an Eakins painting *William Rush Carving His Allegorical Figure of the Schuylkill River* (fig. 5), a scene showing Rush in his studio sculpting from the model. Kline took this idea about re-defining art as "honest work" to be a repudiation of the sentiment that art is "an activity of leisure, perhaps not even a serious endeavor, a comment every artist has heard more than once."[18] *Eakins (for Leo Steinberg)* suggests the curvature and notched intervals of a human spine. While the sculpture echoes the backside of the woman posing for Rush, it also acts to mock by further *undressing* her. Using a tool handle,

14 Martin Kline, interview with the author, March 27, 2011.

15 Hugh T. Scogin Jr., *Rocks and Art: Nature Found and Made.* Exh. cat. (New York: Chambers Fine Art, 2001), 7.

16 Martin Kline, interview with the author, March 27, 2011.

17 Leo Steinberg, *Other Criteria: Confrontations with Twentieth-Century Art.* Revised edition. (Chicago: University of Chicago Press, 2007), 55 et passim.

18 Martin Kline, email correspondence with the author, July 7, 2011.

Kline invokes the human body and the activity of labor simultaneously in an ironic tribute to this great art historian.

Occasionally, the artist's work contains an overtly political dimension. Four sculptures, tangential in his oeuvre perhaps, but nevertheless important, embody a social conviction that is communicated with passion. Three of these are baseball bats (p. 76), an object of popular culture that is intimately tied to revered notions of American mores. Kline has used the baseball bat frequently in his work, and the three presented here address serious social issues. The fourth work is a pair of boots, *Basic Training* (p. 77), that have been bronzed and patinated with a complex camouflage design. All are somber memorials that elicit an emotional response from the viewer, and more vociferously than any of Kline's other work, address the sometimes heavy hand of American democracy.

The genesis of *Basic Training* came from the artist's own military experience and may be read as a complex signifier of both personal and universal experience. Kline has cast several pairs of shoes and boots during his career and his Fort Knox combat boots serve, on one level, as a memento of his military service. On another level, the work acts as more of a universal commemoration to those in the armed services. The boots appear to have been left by their owner, whose absence may suggest that he or she has paid the ultimate price for his/her country. The work sits on the floor like a contemporary stele, an informal marker of loss and sacrifice, a modern day *memento mori*. Kline's engagement with shoes not only recalls the humble paintings of Van Gogh, who used worn out shoes as models, but also speaks to the peculiar American custom of preserving baby shoes by "bronzing" them. Kline remembers these "monuments to baby" were popular during his childhood in Ohio in the 1960s.[19]

Each in the grouping of three baseball bats tackles an important and sensitive issue in American culture. These objects evolved from Kline's scepters that he increasingly recognized were comparable to ceremonial staffs signifying power or dominion and represent both positive and negative sides of American culture. "It occurred to me that the baseball bat was the quintessential American symbol and I came to think of the bat as the American scepter. Baseball is this wonderful and wholesome all-American activity, but bats have also been used as weapons to hurt and kill people. So, they are reflective of the dark side of America, where everything is not as good as it seems."[20] Like other contemporary artists who have incorporated baseball bats into their work including Alison Saar and David Adamo, Kline has found them to be effective within his artistic practice. The grouping of carved bats in Saar's *Bat Boyz* (fig. 6) is a commemorative work similar to Kline's *Jackie Robinson* (p. 76), which memorializes the breaking of the color barrier in the game of baseball and is a celebration of the man and his achievement. Robinson's acceptance was one of the defining moments in sports during the 20th century and holds a special place in the fabric of American culture as a predecessor to the Civil Rights movement. *Jackie Robinson*, like an African nail fetish, is an object filled with found objects such as antique nails and a hand-forged chain and one bronze nail, cast by Kline as an imperceptible mark of the artist's hand. The adoption of these formal elements is not the essentializing of African culture found in some early 20th-century European and American painting and sculpture, but an earnest and emotive tribute to a heroic man.

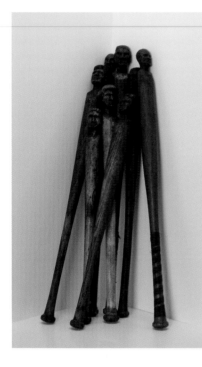

Fig. 6
ALISON SAAR
Bat Boyz, 2001
baseball bats and pitch
34 x 12 x 12 inches
(86.4 x 30.5 x 30.5 cm)
Yale University Art Gallery
Janet and Simeon Braguin Fund

19 Martin Kline, email correspondence with the author, April 23, 2011.

20 Martin Kline, interview with author, May 8, 2011.

Issues of oppression and resistance to a hegemonic power are also found in the baseball bats *OW* (p. 76) and *Kent State* (p. 76). Like *Jackie Robinson*, *OW* refers to a specific figure: playwright, satirist, and one of the great wits of his age, Oscar Wilde. Wilde was prosecuted and jailed for his homosexuality. The bat in this instance is a similarly appropriate type of memorial device and the title, as Kline has noted, invokes an onomatopoeic association by using Wilde's initials to spell the word "ow." The silver nitrate patina is at once a reference to the tarnished silver of the Victorian era, as well as subtly suggesting the tarnished reputation of the great author. *Kent State* has an association for Kline that is geographically much closer to home. Three of Kline's brothers went to Kent State University, in Kent, Ohio. The university is perhaps best known for the tragic incident that occurred on May 4, 1970 when in response to student protests against the Vietnam War, four students were killed and nine others wounded by Ohio National Guardsmen who had been called in to keep order. The event left a deep scar on the tissue of the American consciousness and symbolized the divisiveness of the war. Kline renewed this dilemma in *Kent State*, from 2002, with an eye on America's new conflict with Afghanistan. The added ridges of cast stainless steel in high-relief endow the bat with an aggressive and mace-like quality. This work has a particular resonance with the artist who served in the Ohio National Guard.

Japan, the Infinite, and Beyond

In 2005, Kline accepted an artist's residency in the remote town of Miyakonojo, located on the island of Kyushu in southern Japan. There he created a series of oilstick drawings exclusively in black and white that in many ways relate to and are somewhat reminiscent of his earlier gridded black and white drawings. However, they have a much more Eastern sensibility about them, having broken free from the grid, and incorporate figuration. There is a rigorousness about them, manifested here in the ciphers embedded within the overall composition. This was the third time that Kline worked strictly in black and white as he created ink line-drawings in the 1980s, black and white encaustic paintings in the mid-1990s, and then these oilstick works while in Japan. *Mondrian in Japan* (p. 83) is one of the more representative of this series and not only pays homage to another Dutch artist by recalling some of his early tree paintings, but adapts a character-like series of symbols to create a two-dimensional blossoming form. The artist's stay in Japan was a revelatory immersion into a unique culture. As he wrote in his essay for the *Made in Japan* exhibition, "Being especially interested in the ancient world and cultures, I studied Japan's Chinese roots, ancient legends, shrines and religion; Japanese garden design and Ikebana, and the importance of control over Nature in general; Jomon and Samurai cultures; Tea Ceremony, calligraphy, lacquer, Noh and Kabuki theater. All of these cultural elements filter through a millennium of Feudalism and isolationism to form Japan's present-day culture."[21] The experience continues to engage Kline well after his return to the U.S. as we witness in works such as the deadpan *Ikebana* (p. 85). Ikebana, the Japanese art of flower arrangement, is typically a combination of flowers, leaves, and branches composed poetically. Kline's single monolithic palm leaf in a vase covered with his characteristic treatment boldly defies the Ikebana tradition while at the same time embracing it in this graceful and spare composition.

21 *Martin Kline: Made in Japan.* Exh. cat. (New York: Jason McCoy, Inc., 2006), 5-6.

Following his visit to Japan and perhaps as a deliberate continuation of his work in black and white, Kline created a group of paintings that remained largely devoid of color. These included *Agnes LeWitt* (p. 78) and *Dream of Pollock (for Kirk Varnedoe)* (p. 86), both nods to celebrated figures of modernism. The long horizontal format of *Dream of Pollock* recalls the seminal abstract expressionist's large canvases from the early 1950s. In his painting, Kline works from a dense central position, the black, white, and silver drips becoming increasingly lace-like as they move to the edges. *Agnes LeWitt* is a somewhat humorous conflation of two artists who were known for working with the grid: Agnes Martin and Sol LeWitt. While Sol LeWitt's grids were precise and exacting, Agnes Martin, like Kline, embraced the altered, imperfect, or irregular grid form. Both of these works carry a slight suggestion of the infinite. We can imagine *Dream of Pollock* extending far beyond the boundaries of the panel, while *Agnes LeWitt*'s repeated dots, raised-up in the center and diminishing toward the edges, create a field of infinite expanse.

The work most suggestive of boundlessness is Kline's tondo, *Intimate Universe Revisited* (p. 95). The concepts of the infinite and the universe, which perhaps could be considered one and the same, are subjects that have been tackled by many. In Kline's painting the viewer's eye is drawn to the center of the painting as the scattered pattern of the encaustic around the edge becomes increasingly dense and draws closer to the middle. One of Kline's larger tondos, it is nevertheless a microcosmic and metaphoric view of the universe, an *intimate* infinite nearer to that of Japanese-born artist Yayoi Kusama. Kusama is known for incorporating obsessive repetition into her work. These two artists have a shared sensibility and the most obvious comparison may be with Kusama's dot and *Infinity Net* paintings. Conceptually, as well as aesthetically, many of Kline's works, especially *Intimate Universe Revisited*, however, relate more directly to Kusama's infinity rooms, such as *Fireflies on the Water* (fig. 7). Both artists are rendering the infinite: the tondo format of *Intimate Universe Revisited* has many historical associations that could suggest either ancient terrestrial or celestial maps and does not read in a sequential fashion like a more conventional rectangular format. It is a work with no end or beginning and appears to stretch into a boundless world. Likewise, Kusama's constructed environment with mirrors on all sides and a pool of water as a floor, creates an infinite and mesmerizing recession when experienced in person.

Recently Kline has embarked on variations in his encaustic technique with a new body of work that harks back to Demuth's *My Egypt*. This series, which Kline titled *Excursions,* carry with them specific cultural references to cities, areas, places outside the orbit of Far East and West and instead point to an interest in the exotic locales and history of the Middle East. By their titles alone, *Aladdin* and *Gupta* (pp. 96 & 97), we associate these paintings with a specific place. *Aladdin* incorporates a monochromatic palette of blue on the left side and alternating blue and red vertical stripes on the right in a tall tower formation. The title refers to the folk tale of an impoverished youth, whose discovery of a magic lamp brings him power and riches. In this familiar fable, the genie responsible for Aladdin's wealth is summoned by rubbing the lamp. In the painting, the broken stripes of color cascade down from a single point in the upper center of the painting, emphasizing the vertical nature of the work and evoking the emergence of some mystical force, the genie, perhaps. The cultural references in these works run deeper than mere narration, however.

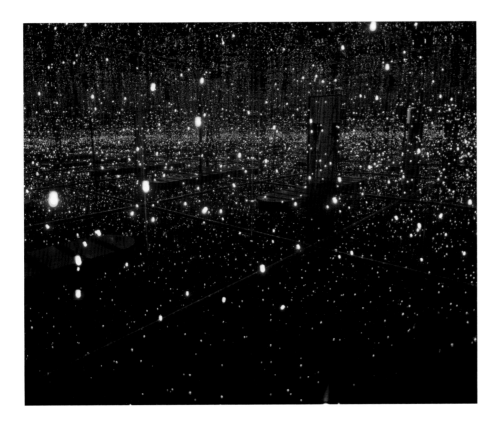

Fig. 7
YAYOI KUSAMA,
Fireflies on the Water, 2002
mirror, plexiglass, 150 lights, and water
111 × 144½ × 144½ inches
(281.9 × 367 × 367 cm) overall

Whitney Museum of American Art, New York;
purchased with funds from the Postwar
Committee and the Contemporary Painting
and Sculpture Committee and partial gift of
Betsy Wittenborn Miller 2003.322a-ttttttt.
Photograph courtesy of Robert Miller Gallery

Aladdin's emphatic vertical orientation and domed top allude to the distinctive
feature of Byzantine Islamic religious architecture, the minaret, prominent in many
a Middle Eastern skyline. *Gupta* carries with it similar cultural associations and is
a return to chromatic variation not seen since his *Yucca* watercolors. The diagonal
stripes are like bolts of richly patterned Indian fabrics on display. As writer Eleanor
Heartney noted about this body of work: "Drawn from Kline's interest in ancient
cultures, these paintings present legendary cities as capitals of the imagination
which stem from actual travel experiences as well as the mind's-eye invention of
places of lands he is drawn to but has yet to visit."[22] They are in no way cultural
appropriation, but instead cultural appreciation similar to that of some of the Pattern
and Decoration artists such as Joyce Kozloff, Robert Kushner, and Miriam Schapiro,
who in the 1970s explored similar Eastern- and Near Eastern-inspired themes in
their work.

Throughout his career, Kline has achieved an enviable balance of seriousness
and wit in his paintings and sculpture manifesting cultural references both weighty
and amusing. Humor is revealed in works such as *Bride of Frankenstein* (p. 101), a ref-
erence to the 1935 horror film derived from the subplot of Mary Shelley's novel
Frankenstein and a sequel to the original film of 1931. The large oval format in stark
white with an opening bloom in the center recalls the flowing white robe and volu-
minous hair of Elsa Lanchester's fearful bride. But there is more to the work than a
simple play on a seminal cinematic science fiction tale. The piece is tempered by a
more serious subtext as the title character's name brings to mind associations of
science gone horribly wrong, an issue of infinite resonance in our present time.
This theme is one that has captivated the artist and continues to provide him with
fruitful subject matter.

22 Eleanor Heartney, *Excursions with Martin
Kline*. Exh. cat. (Houston, TX: Meredith
Long & Company, 2011), 4.

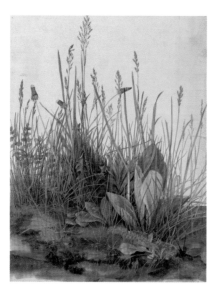

Fig. 8
ALBRECHT DÜRER
Large Piece of Turf, 1503
watercolour, gouache, with
opaque white
16 x 12⅜ inches
(40.8 x 31.5 cm)

Albertina, Vienna

Fig. 9
MARTIN KLINE
Great Piece of Turf, 1998
encaustic on panel
12¾ x 12¾ x 2¾ inches
(32.4 x 32.4 x 7 cm)

Kline has never stopped looking at Old Master works and he has paid homage—at least twice—to Albrecht Dürer's famous and fastidiously painted watercolor, *Large Piece of Turf* (fig. 8) in the collection of the Albertina in Vienna, where he recently had the opportunity to view it privately. Dürer's exceptional draftsmanship is on full display in this seemingly random assortment of vegetal life with green stems overlapping to create a lush still life. Having admired this work since his student days, the artist made his own *Great Piece of Turf*, in encaustic in the late 1990s (fig. 9) and revisited the subject in a 2010 monochrome work entitled *Grey Turf* (p. 100), which is a return to the overlapping forms of his early drawings as its tangle of woven sinuous wax lines appears to radiate from the center of all four edges of the panel.

Kline's interest in Japanese culture continues to appear in his work. *Waking Dream for Kurosawa* (p. 102) is an expansive juxtaposition of light and dark rendered in a gradual transition. The title is a reference both to Japanese director Akira Kurosawa's legendary black and white films as well as the notion of a waking dream, the fusing of fantasy and reality threaded throughout Japanese literature. The seamless blending of these elements exhibits a similar visual manifestation in the photographs of Hiroshi Sugimoto in which ground and sky often meld indistinguishably into a deep spatial recession. In fact, Kline titled another work from this series, *Kurosawa Sugimoto* in tribute to both artists. As abstract as some of Sugimoto's imagery, *Waking Dream* is an inadvertent play (as Kline was not aware) on the title of the 1990 magical realism film by Kurosawa, which the latter based on his own dreams. The pronounced horizontal format of the painting underscores its association to landscape and sky and is intensified by the carefully graduated juxtaposition of stark white and obsidian-like black in this ethereal composition.

A more abrupt contrasting formal dichotomy found in opposing rectangles is introduced in the painting entitled *Romantic Nature* (p. 98). In many ways, this work singularly illustrates the overarching theme of the exhibition. Kline's interest in the natural world has taken a historical dimension, as the artist recently discovered a kindred spirit in naturalist Alexander von Humboldt. In his Romantic conception of nature, Humboldt attempted to unify the branches of scientific knowledge and proposed a view of the natural world that was all encompassing and that stressed the interconnectedness of all aspects of the universe. He took the position that humankind did not have *dominion* over nature, and that humanity's imprint could easily harm or destroy it as the damaging effects of the Industrial Revolution were unfolding before his very eyes. These ideas, once greatly influential, existed at the the early stages of industrialization, when the rapidly expanding study of nature was evolving from a Romantic interpretation to a more rationalized (and therefore presumed greater) understanding of it. Humboldt believed there was a symbiosis in all of nature and that society's careless interference with it could lead to its destruction, an idea that has absolute resonance today.

Kline's affinity with the concerns of Humboldt and other essayists and naturalists of that generation is shared in his metaphoric painting *Romantic Nature*. While its horizontal format suggests a traditional landscape, the work is free of any possessive associations or dominion over the land found in more typical depictions. The honey yellow and burnt umber of the monochrome found in each half conjures a moody quality similar to that of visionary American landscape painters Ralph Albert Blakelock or the proto-modernist Albert Pinkham Ryder. The painting

lacks a conventional horizon line, the hallmark of a traditional landscape, although the encaustic application surges into a higher relief across the center of the panel. Kline is not after a literal rendering of physical space, but an abstracted embodiment of contradictory yet interconnected, and most importantly, interdependent ideas. The two halves of the painting are more than simple monochromatic rectangles but serve as complex signifiers that suggest a harmony between opposites. The dialectic of Kline's work is thus reinforced and reiterated with the yin yang concept in Chinese philosophy; each side is the complementary opposite to the other and in fact *needs* the other to exist. Kline's articulation of this notion in *Romantic Nature* takes on much greater resonance not only within the context of the artist's oeuvre, but serves as a metaphor for addressing the complex problems of a growing human race. As Humbolt declared in his *Cosmos*, a balance between the natural world and increasing demands for more resources must be found.[23]

Conclusion

Working across disciplines, Martin Kline synthesizes formal, cultural, and conceptual elements with clarity and innuendo. In the words of Barbara Rose, the artist's works "define themselves as experiences in time and space whose processes and materials replace the academic images and narrations of earlier art as significant content."[24] Kline's paintings and sculpture are *experiential* and viewing his work retrospectively illustrates a number of evolving themes throughout the artist's career, showing us that he is essentially an autodidact whose work has been conceptually driven throughout. At the same time, he has developed a unique encaustic process with an emphasis on the haptic that often stimulates a desire to physically touch his works. Kline's interests have broadened considerably over time and his work has taken on a greater sense of gravitas in creations that address social, political, and identity issues. By far, however, the most prominent theme amongst these is an insightful if remonstrative commentary on the natural world.

Kline's conception of the natural world and our connectedness with it is inextricably linked to a long lineage of Romantic thinkers on nature stretching back to the 18th century. It is a group that includes writers such as Coleridge and Wordsworth, naturalists Emerson, Muir, Thoreau, and Humboldt, and artists Thomas Cole, George Inness, and others who reflected the assessment that nature was not something to simply be culled for scientific purposes or appropriated for indiscriminate human advancement. Instead, these figures, Kline included, recognize that humanity is intricately linked to the natural world which should be responsibly conserved and sensitively cultivated. Today these ideas are prominently manifested in the wider context of land use, sustainable energy and green technologies, accountable management practices, and other topics frequently at the forefront of our contemporary consciousness. In Kline's work these notions are not expressed in a moralizing, heavy-handed way, but in thoughtful doses of humor, grace and contemplation.

23 *Kosmos*, or *Cosmos* in English, was published in two volumes: Alexander von Humboldt, *Cosmos: A Survey of the General Physical History of the Universe*. Vol. I. New York: Harper & Brothers, 1845. Volume II was published a few years later.

24 Barbara Rose, *Anti Icon*, 11.

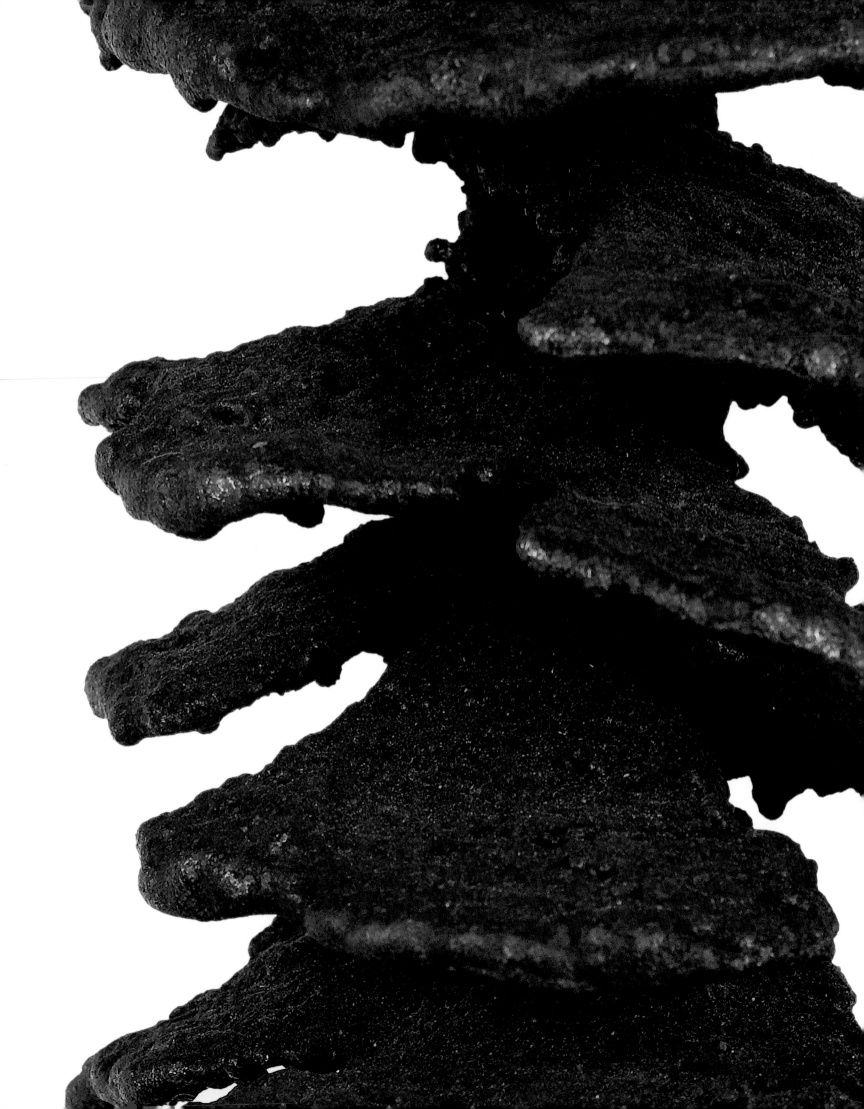

Exhibition Works

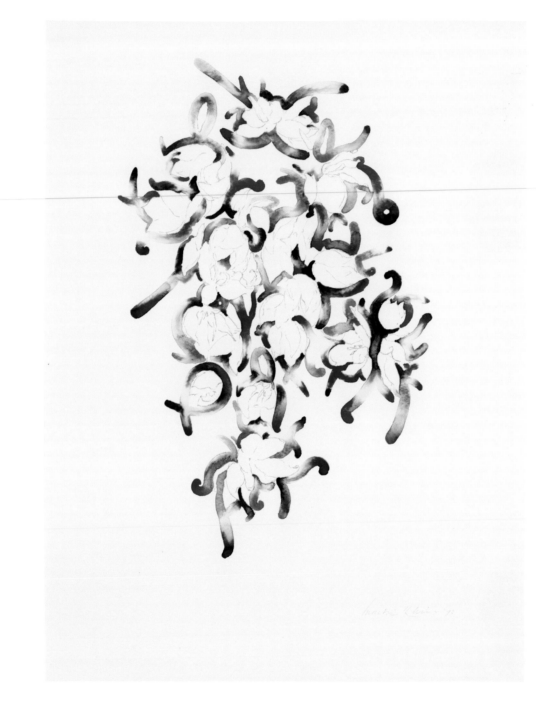

Yucca (#18), 1993

Emblem, 1994

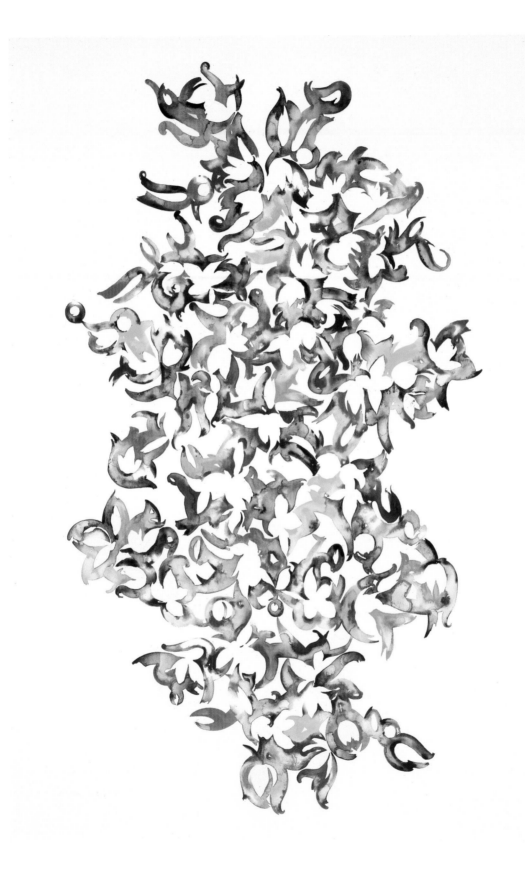

Grid Abstraction, 1994

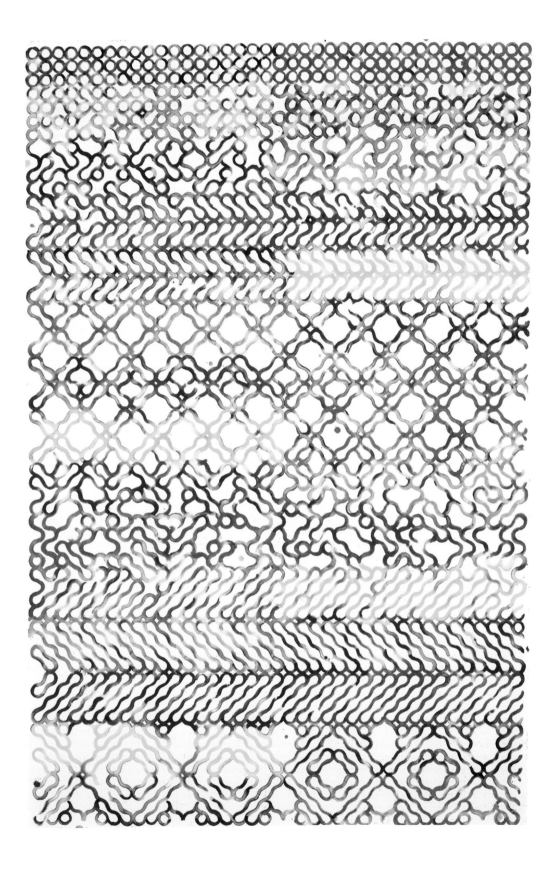

Grid (Tapestry), 1996

Ode to the Grid (#1), 1994

Once upon a Cloud, 1997

Labyrinth, 2001

Liquid Grid IV, 1996

Tempest, 1998

Epiphany, 1997

Black and White Diptych, 1997

Dream of Betsy Ross, 1997

Spring, 1997

Summer, 1997

Autumn, 1997

Winter, 1997

Daily News, 1997

Crucible, 1998

Waste Not, 1999

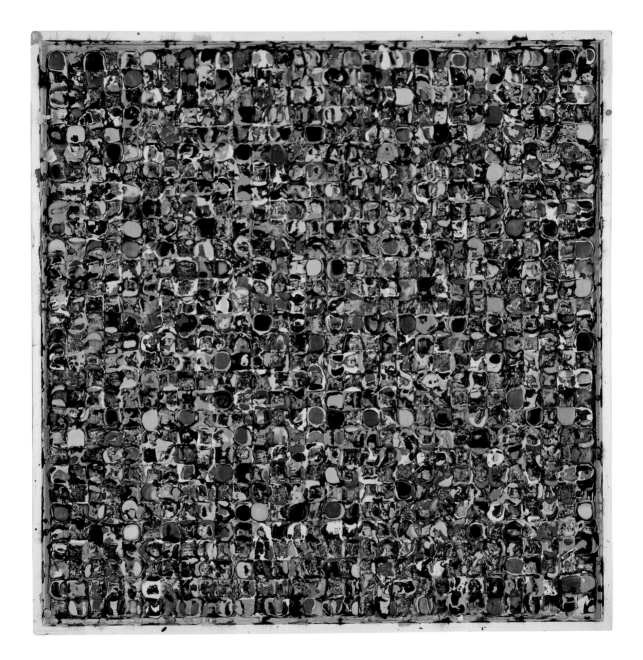

Cake, 1998

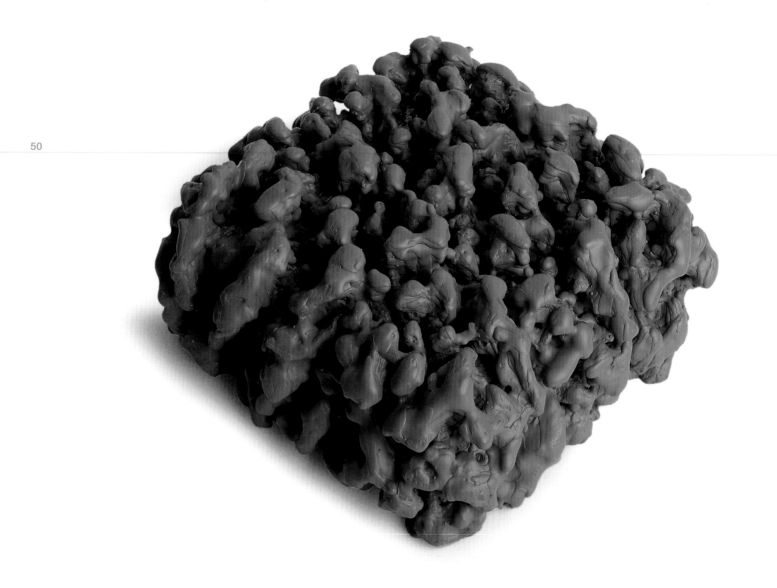

Charm, 1998

Culture, 1998

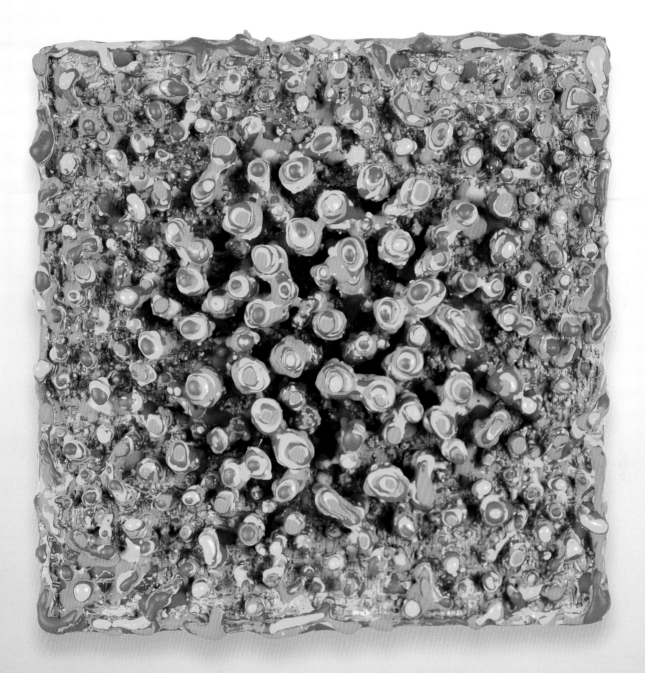

Wax Lips for Monica Lewinsky, 1998

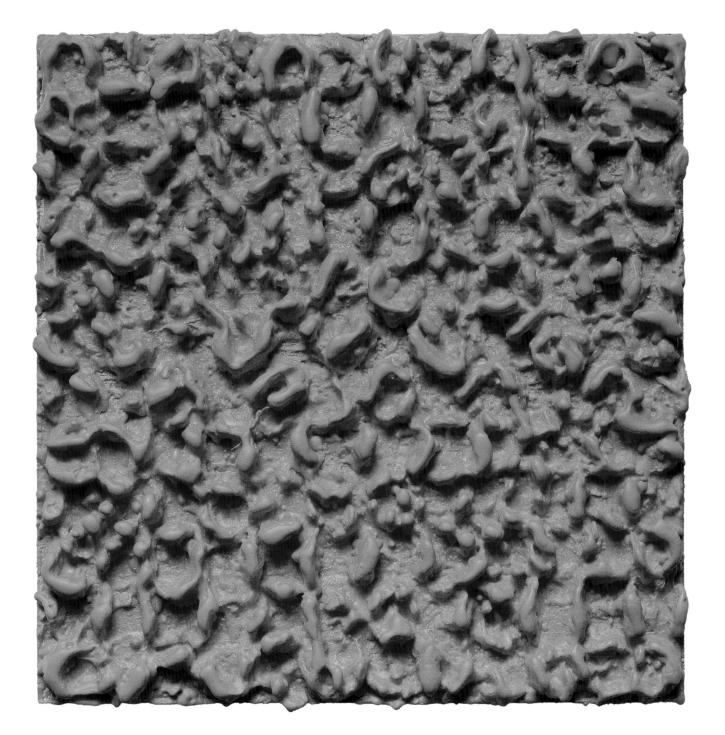

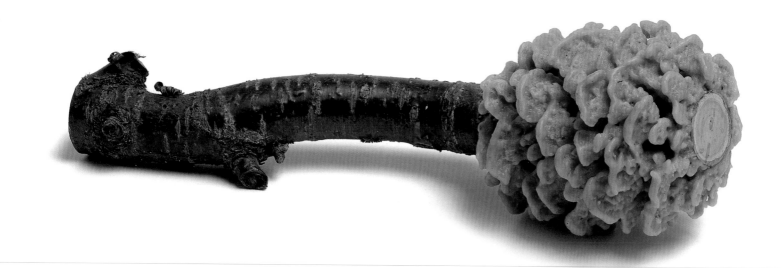

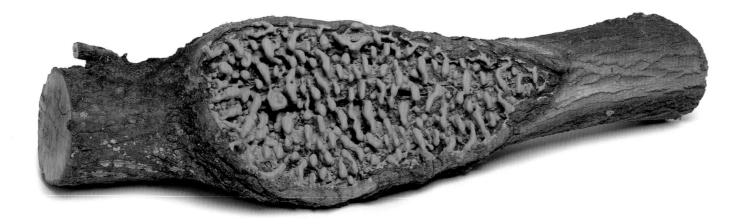

Scepter, 1999

Wound, 1999

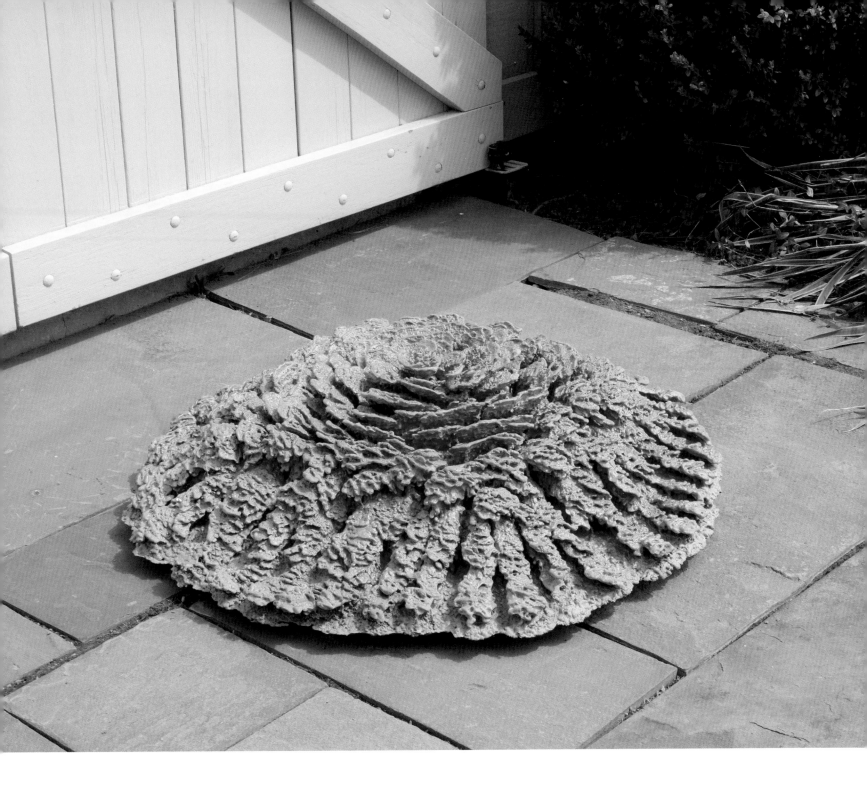

Dream of Mary Shelley, 1999

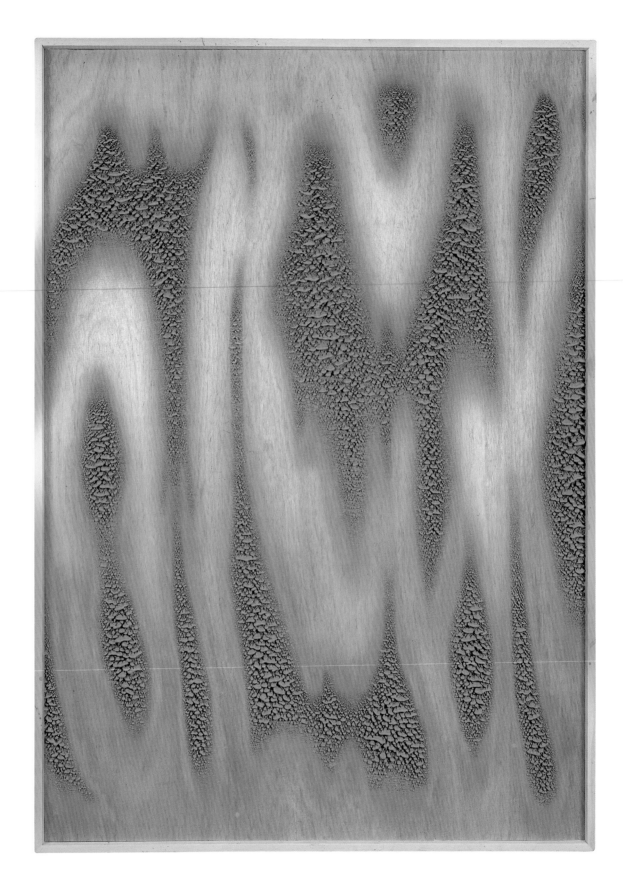

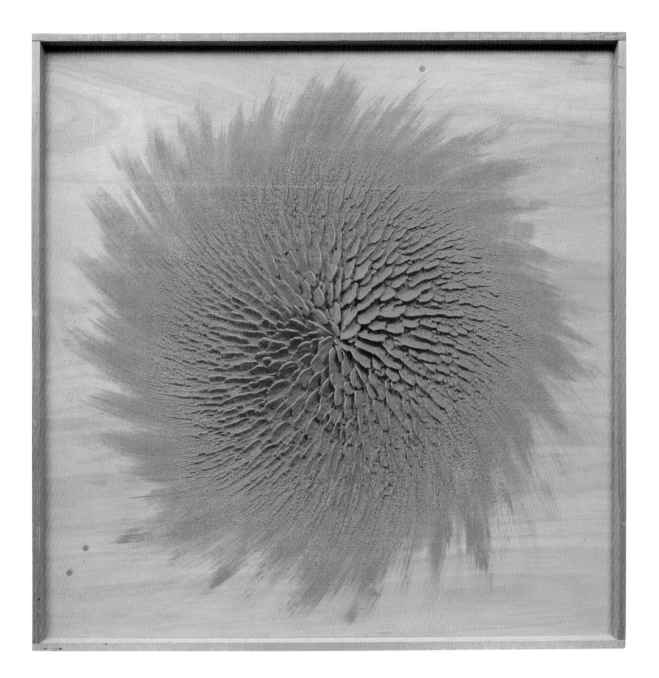

In The Lab, 1999

Randazzo, 2000

Cosmos, 2000

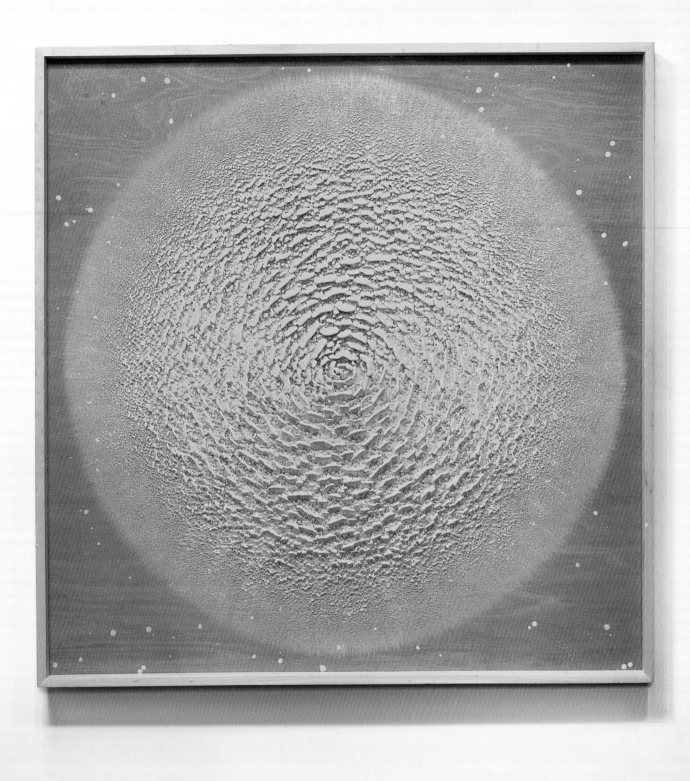

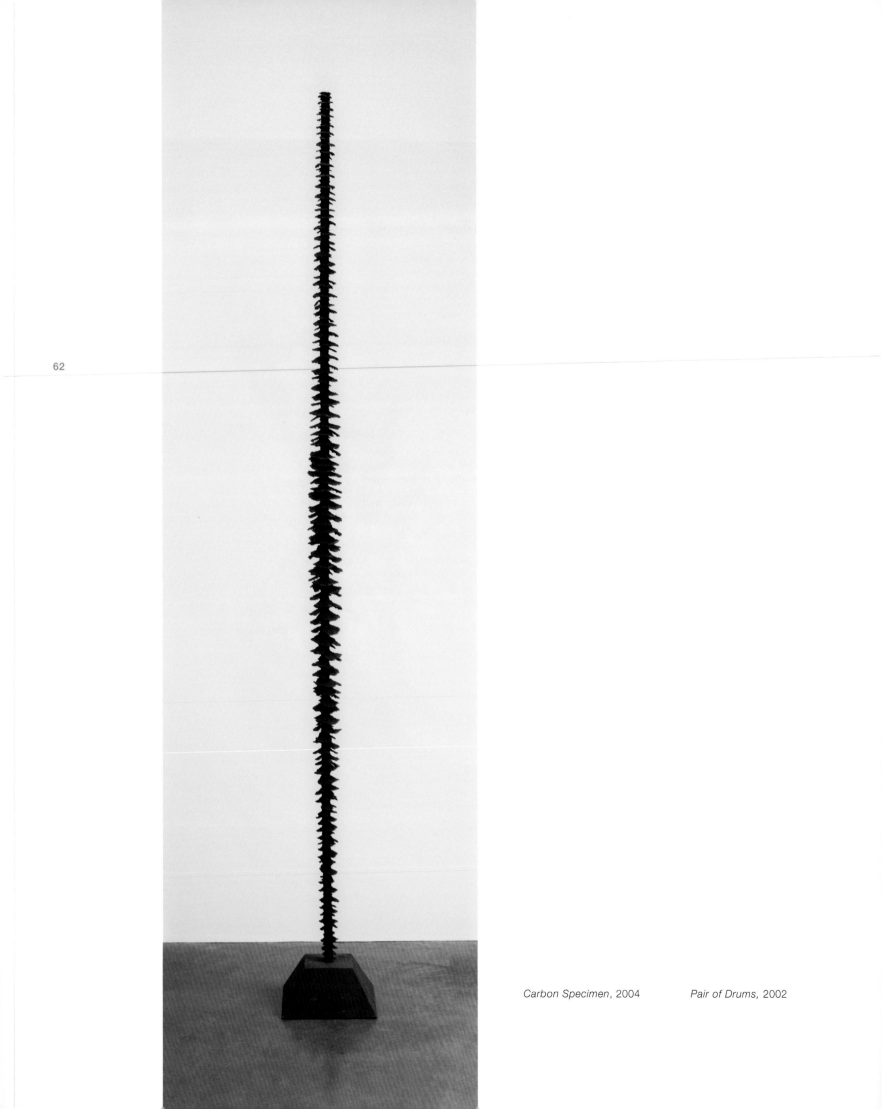

Carbon Specimen, 2004 *Pair of Drums,* 2002

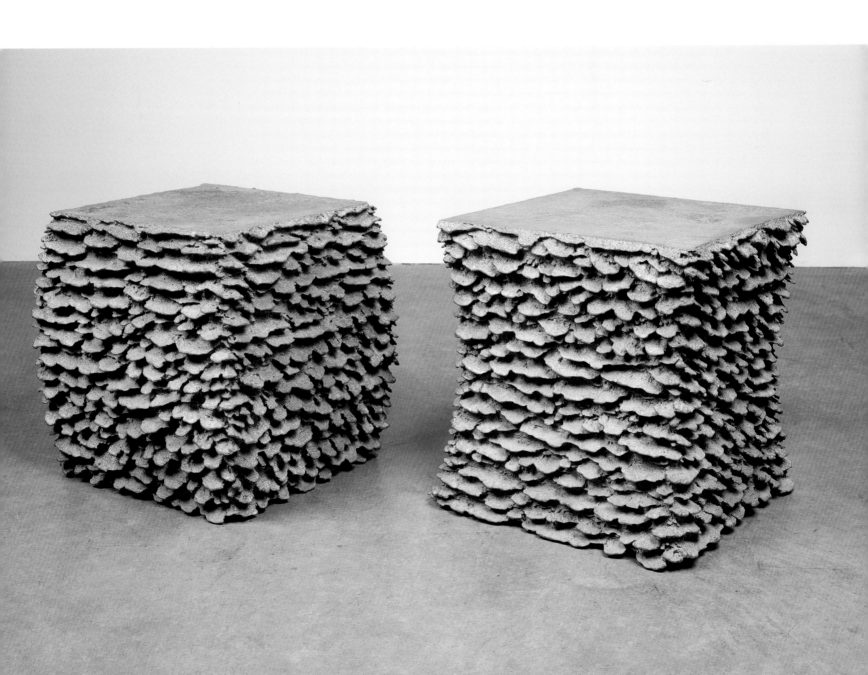

Journal Entry, 2001

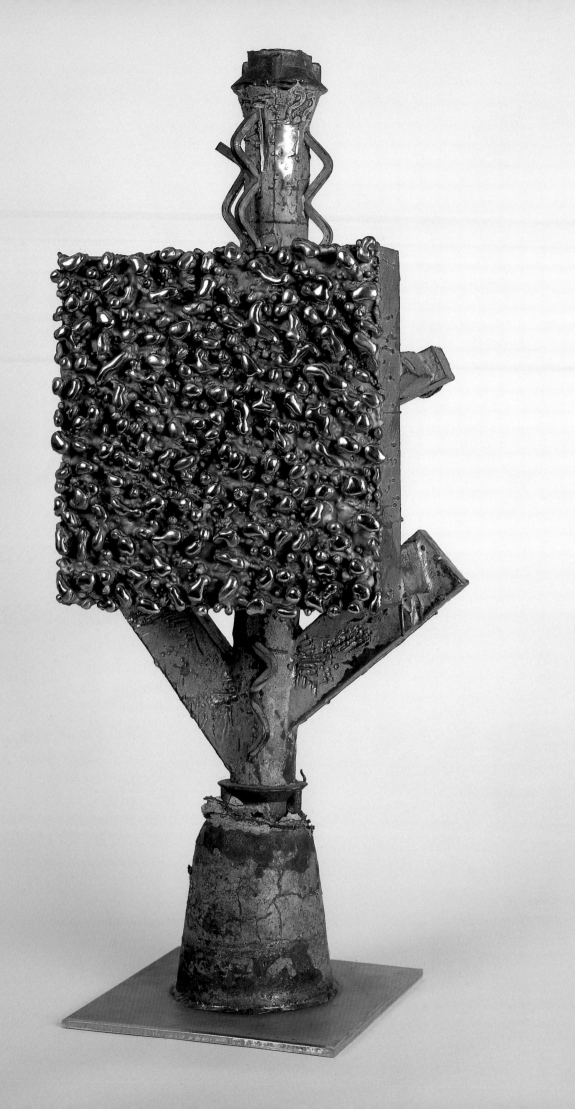

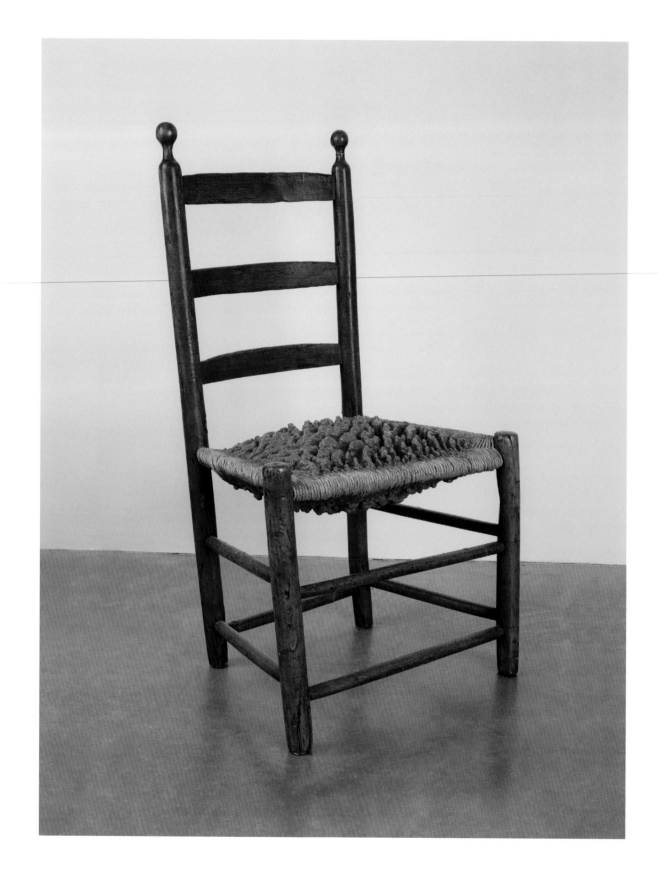

Van Gogh, 2001

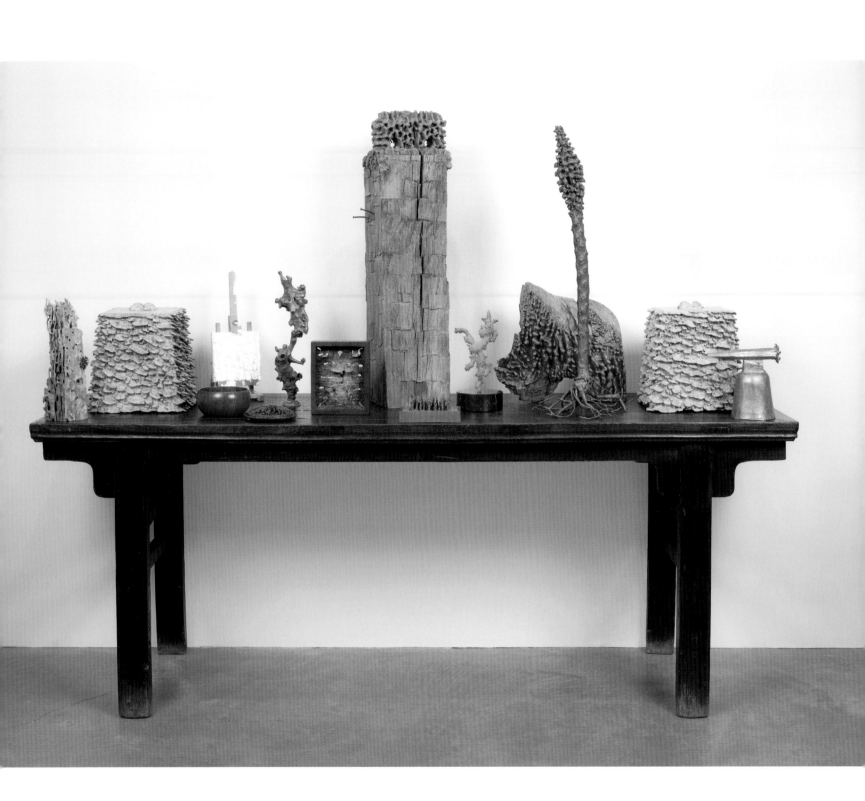

Scholars table with 13 objects, left to right:

Sage, 2010

Imperial box, 2003

Banzai!, 2008

Model for Painting Sculpture, 2010

Scholars Rock, 2007

Little View for the Scholar, 2001

Yayoi (#4), 2006

Martin's Sushi Special, 2006

Emperor, 2002

Torso, 2001

Personnage, 2000

Imperial box, 2003

MOT, 2001

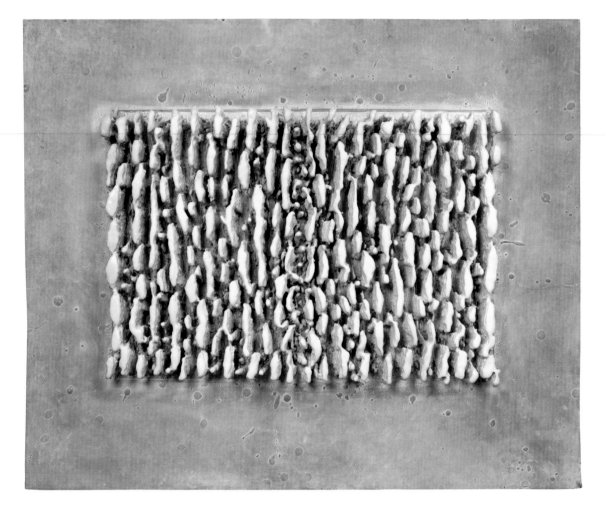

Cast Drawing, 2001

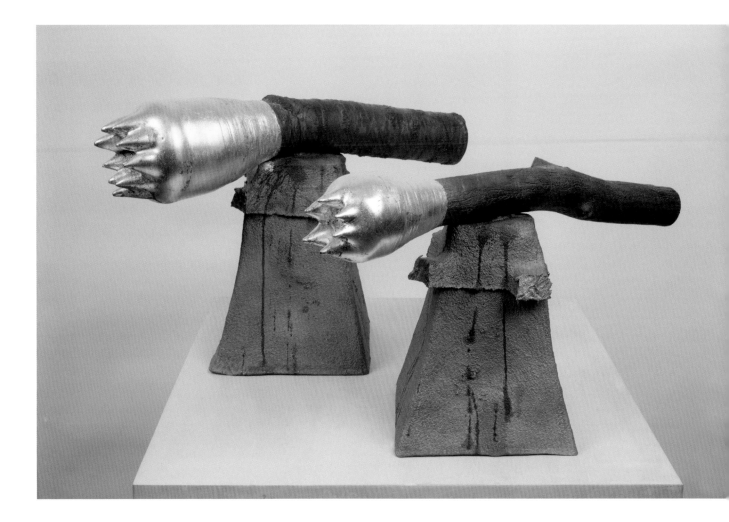

King (left), 2000

Consort (right), 2000

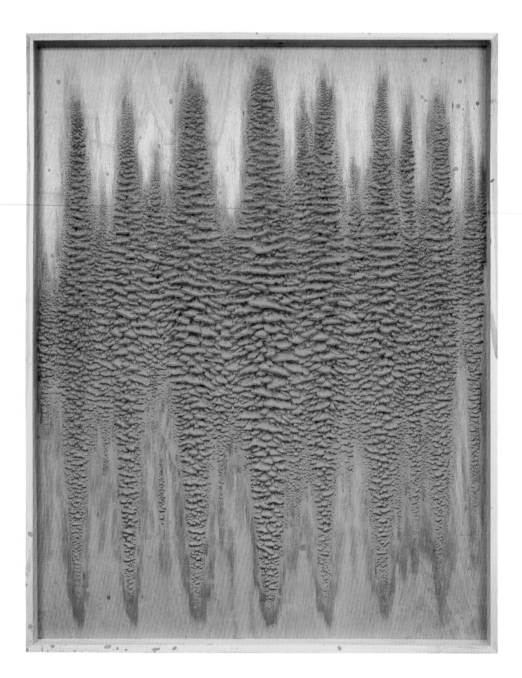

Empoisonner, 2001 and 2007 *Great Expectations*, 2002

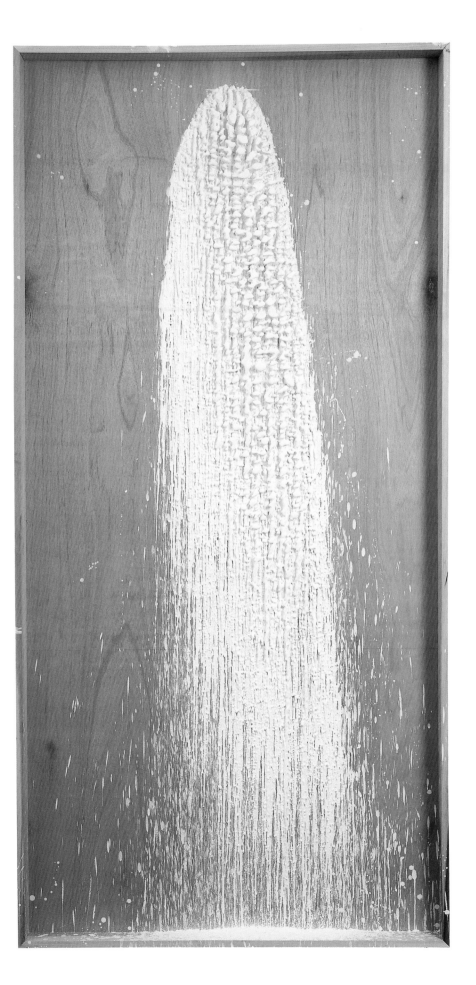

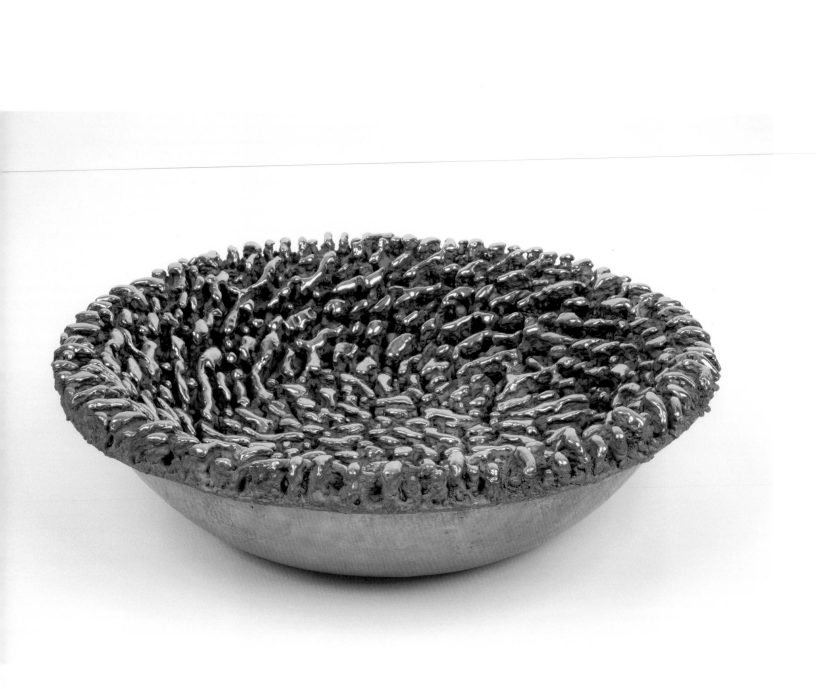

Stainless Bowl, 2003

Axis Mundi, 2002

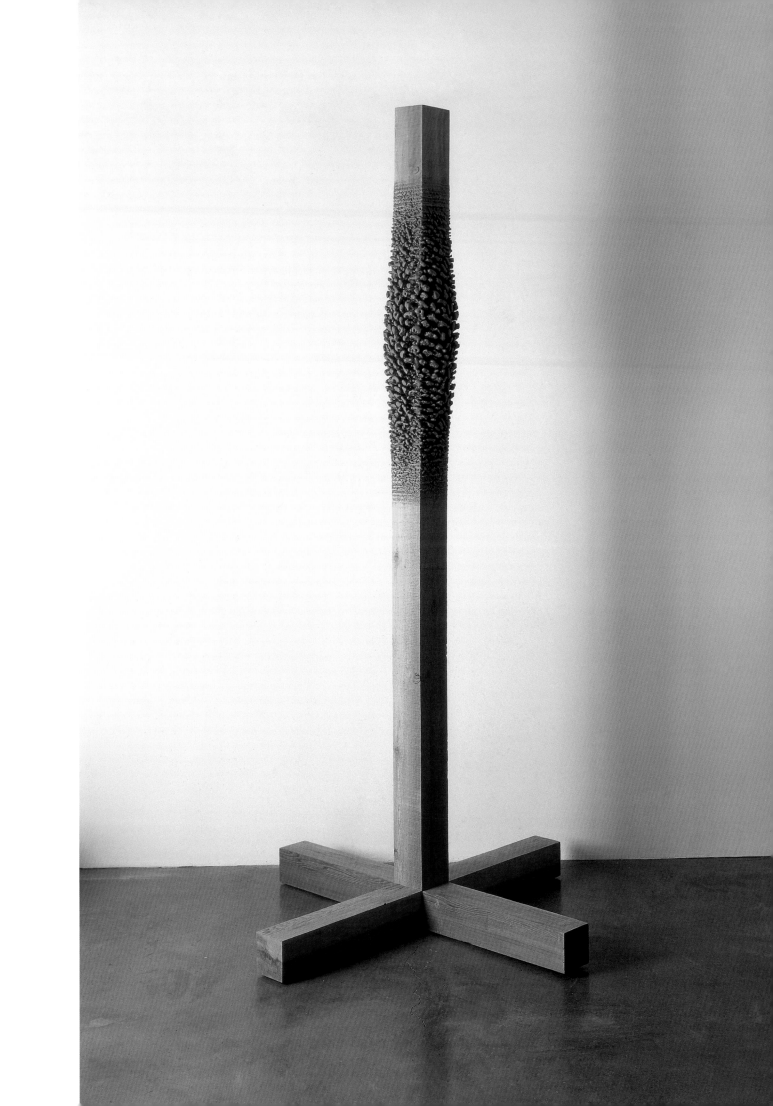

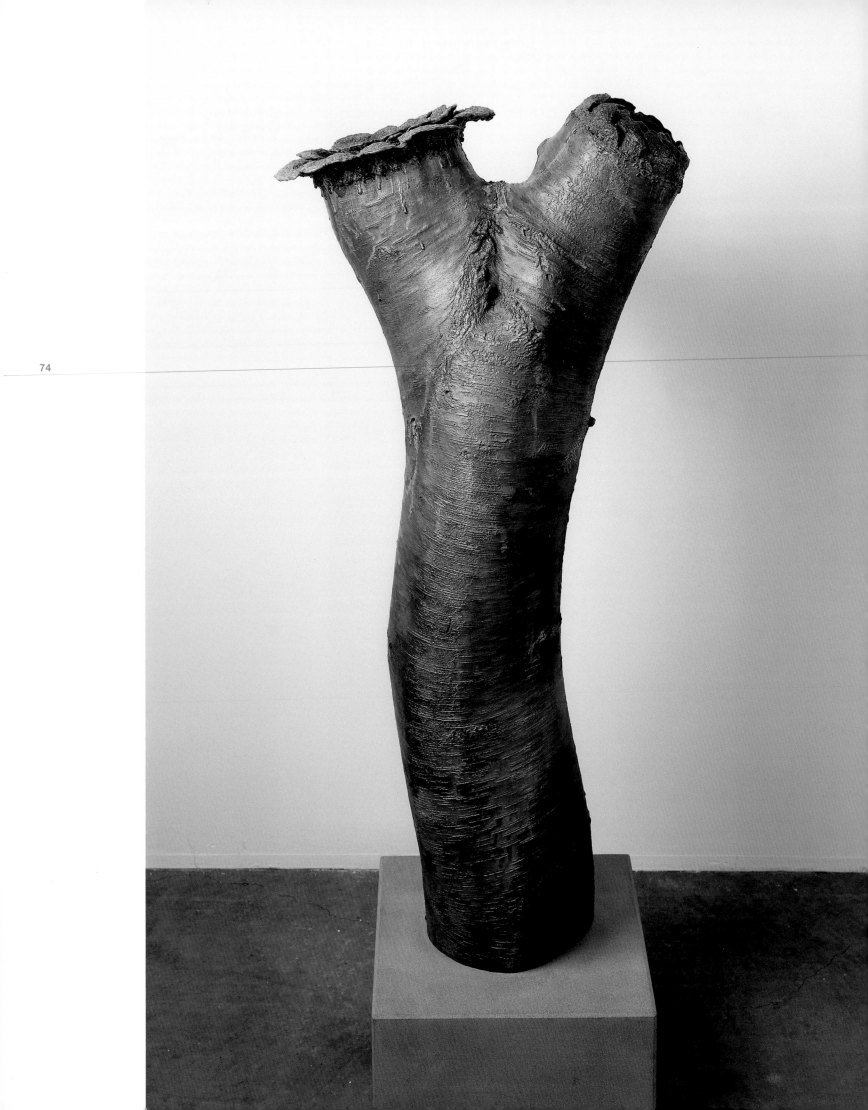

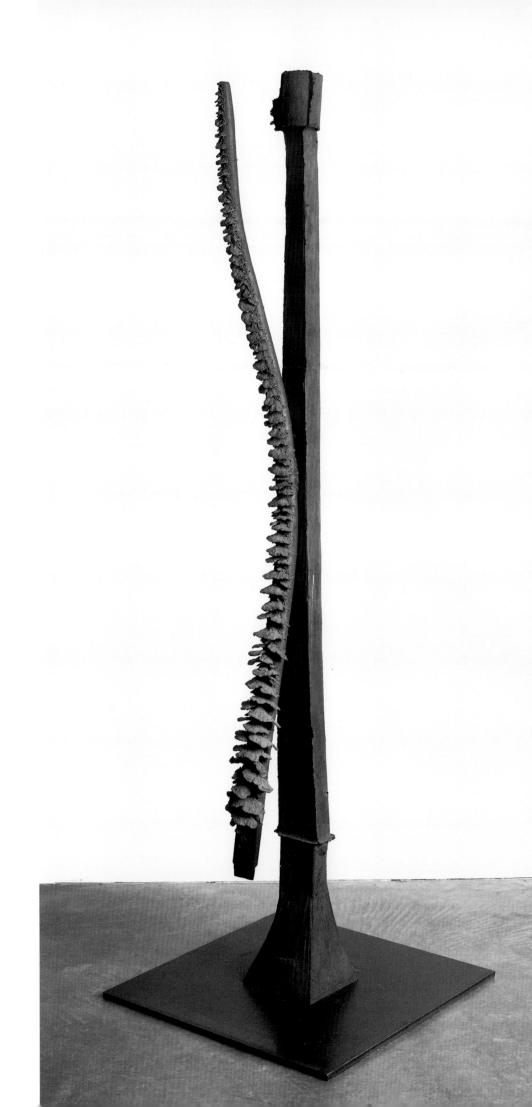

Torso, 2002

Eakins
(for Leo Steinberg), 2002

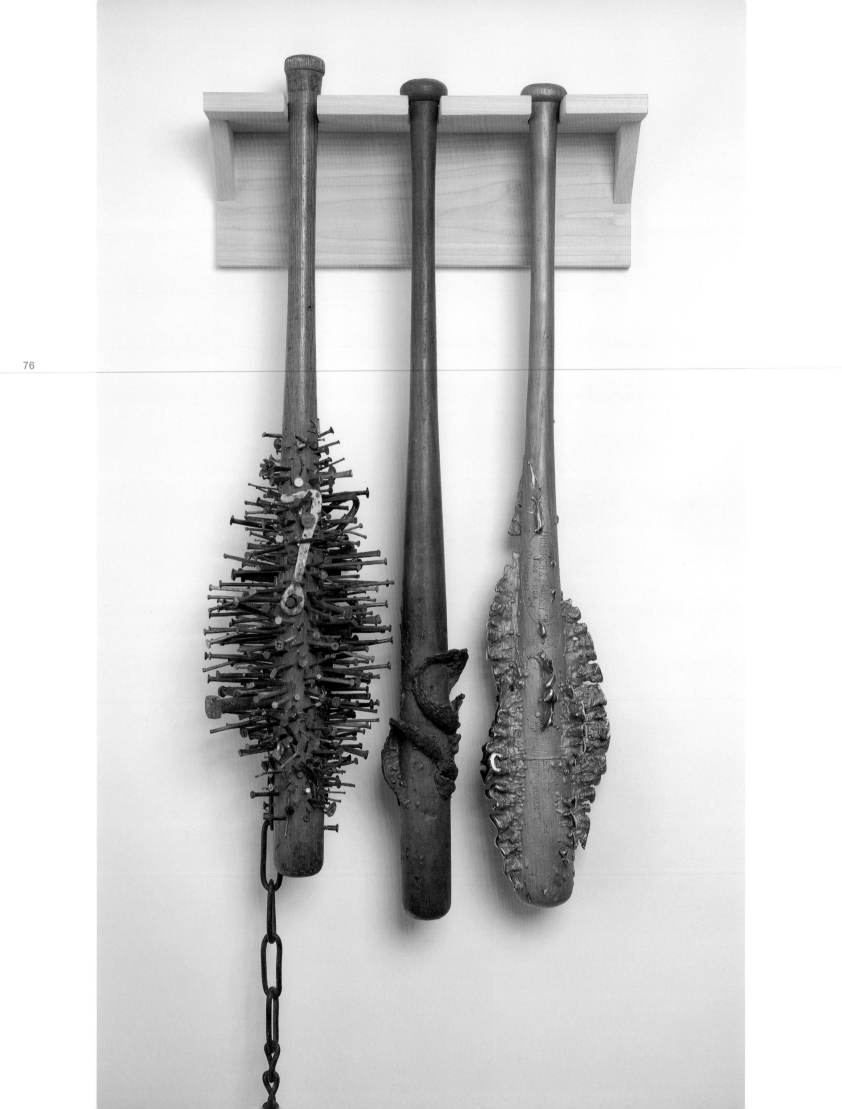

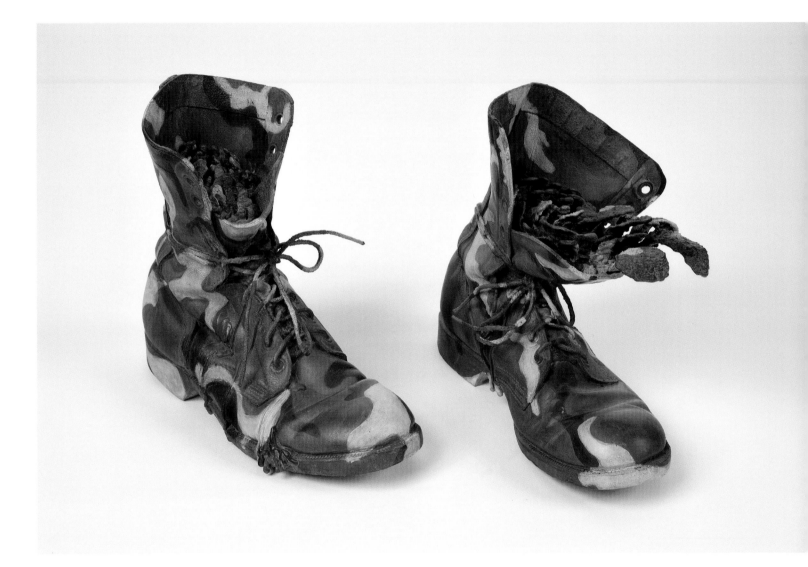

Jackie Robinson (left), 2005

OW (middle), 2005

Kent State (right), 2002

Basic Training, 2005

Agnes LeWitt, 2007

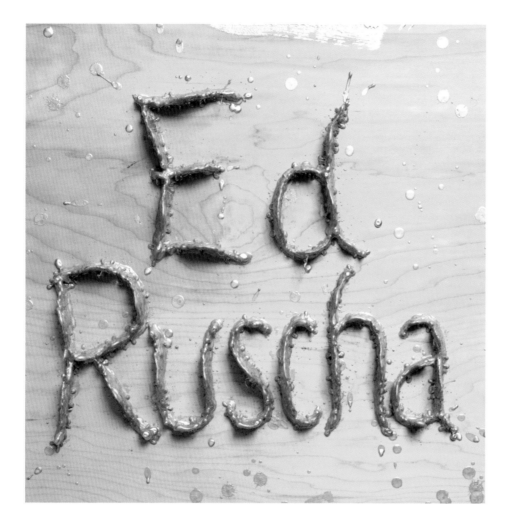

Ed Ruscha, 2004

Secret Garden, 2006

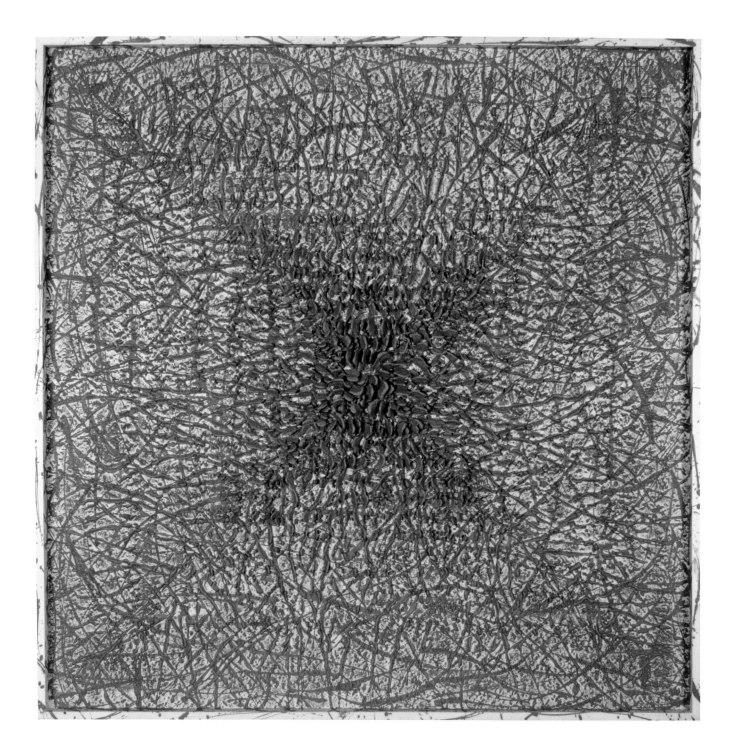

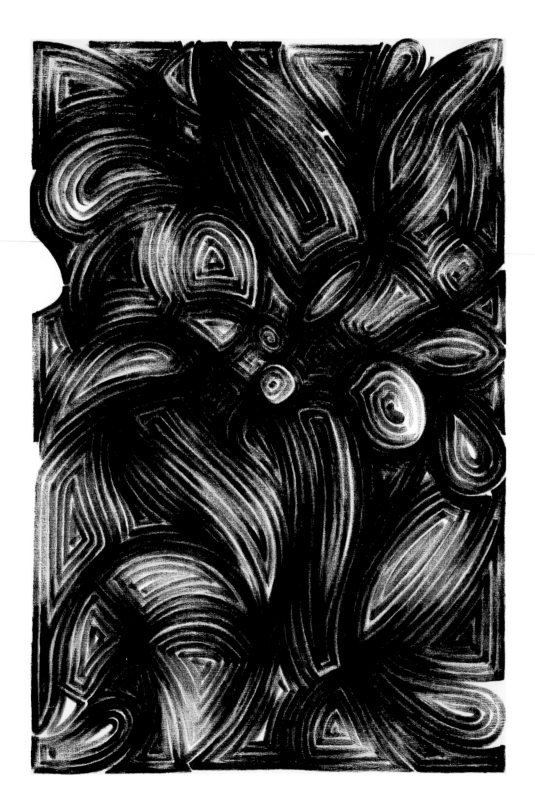

Lush Life, 2005

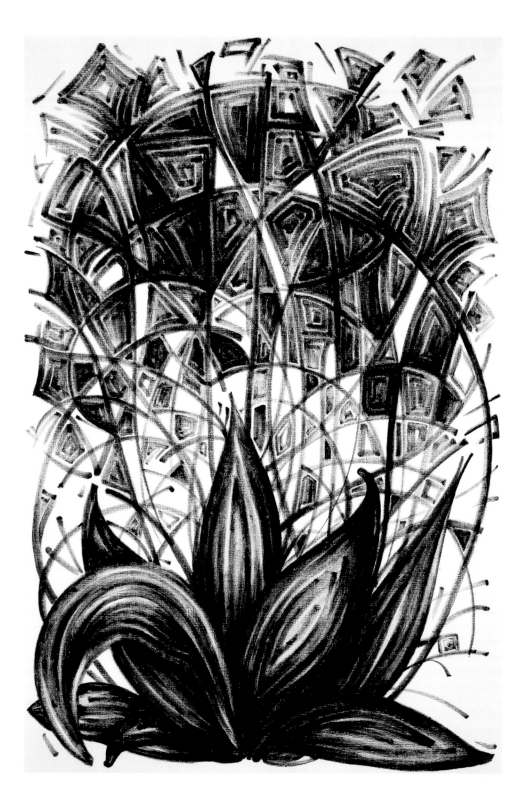

Mondrian in Japan, 2005

Ikebana, 2008

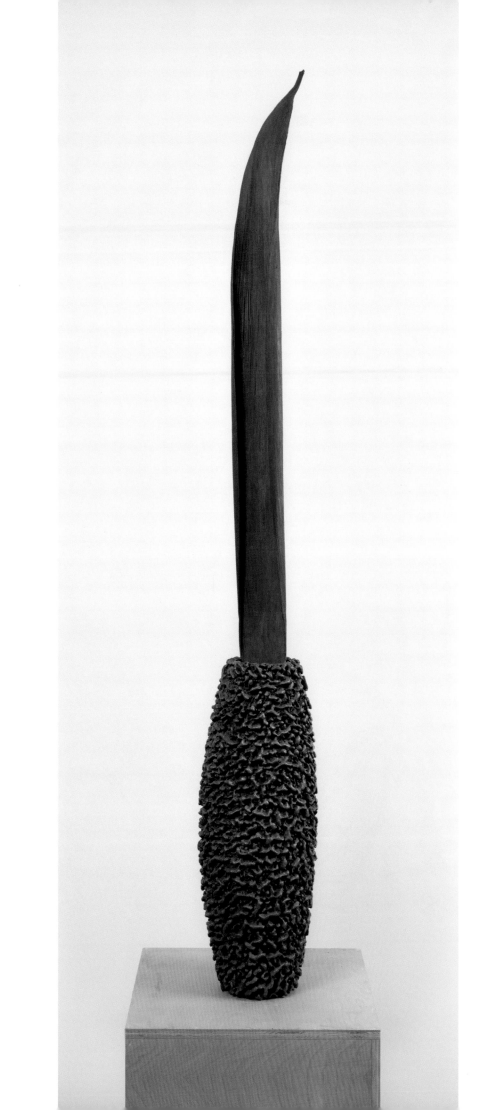

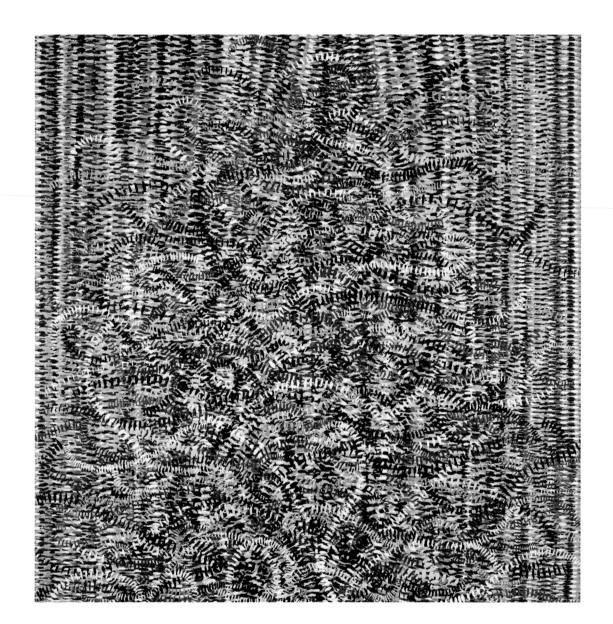

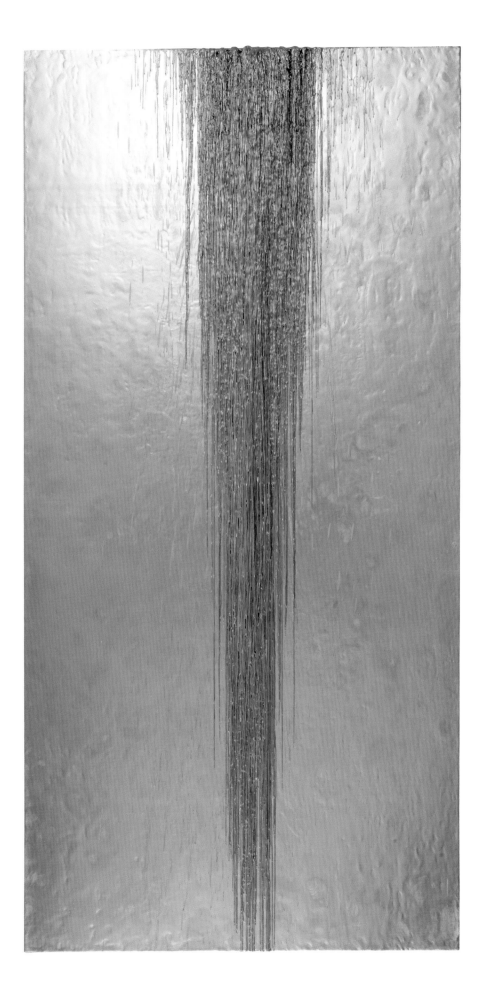

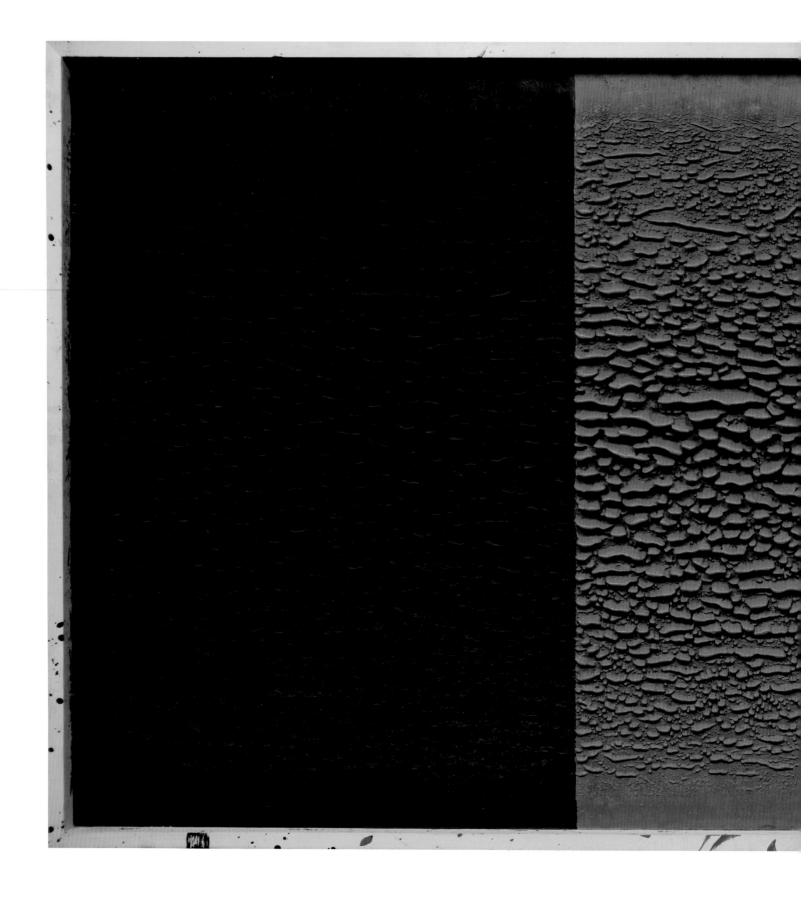

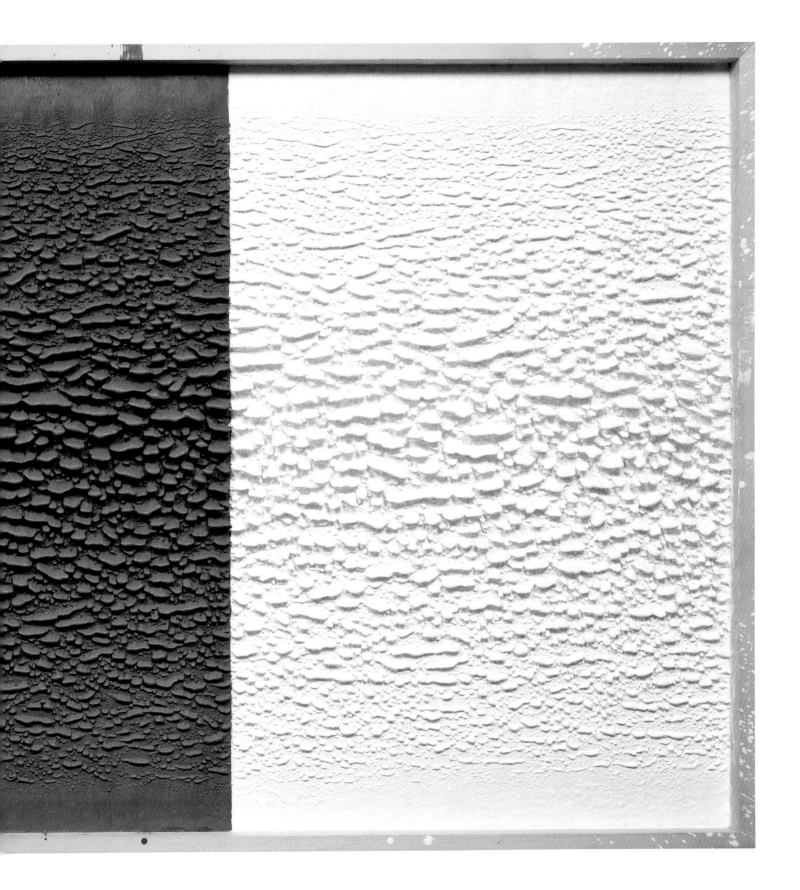

Read Red, 2008

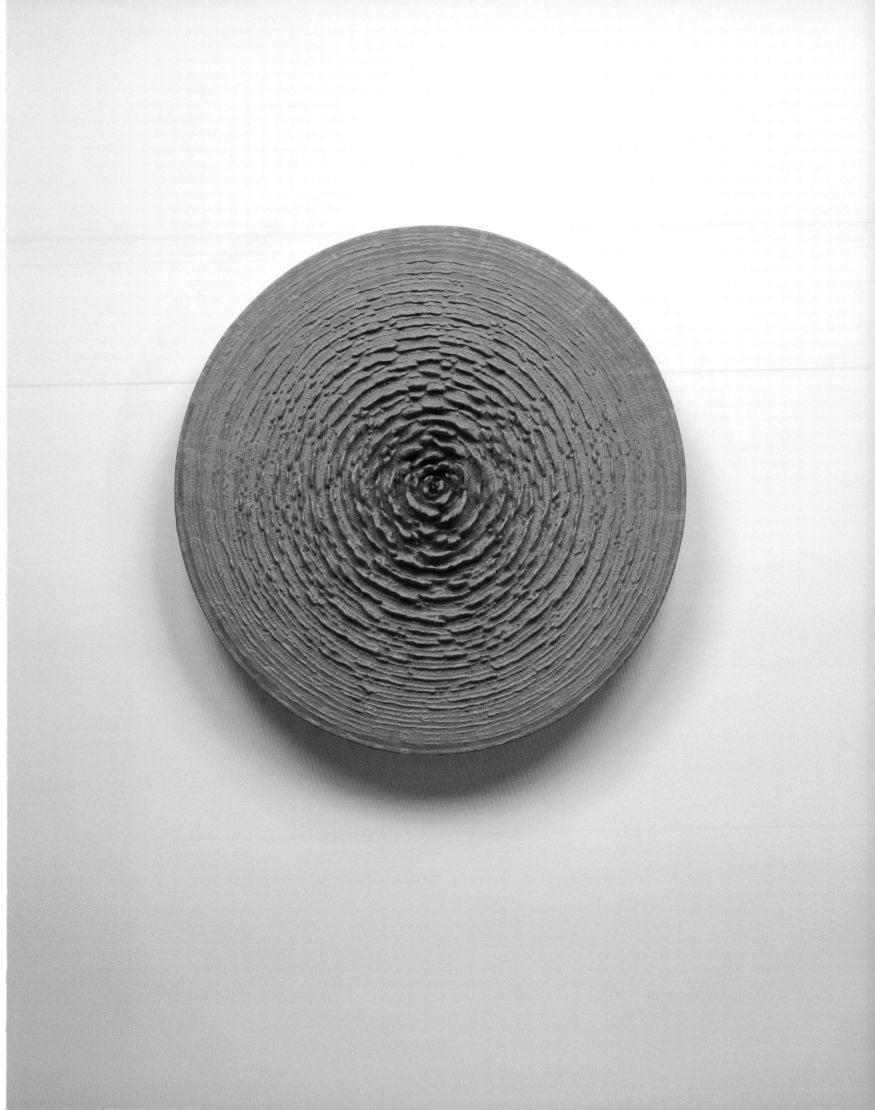

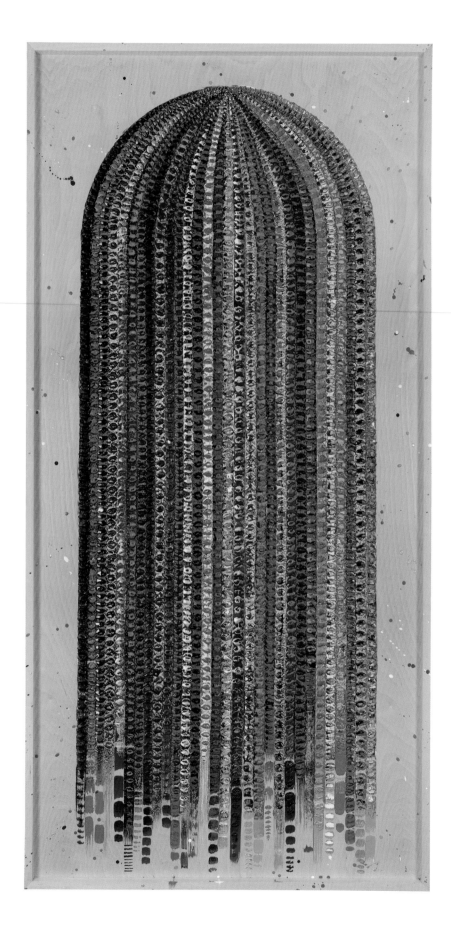

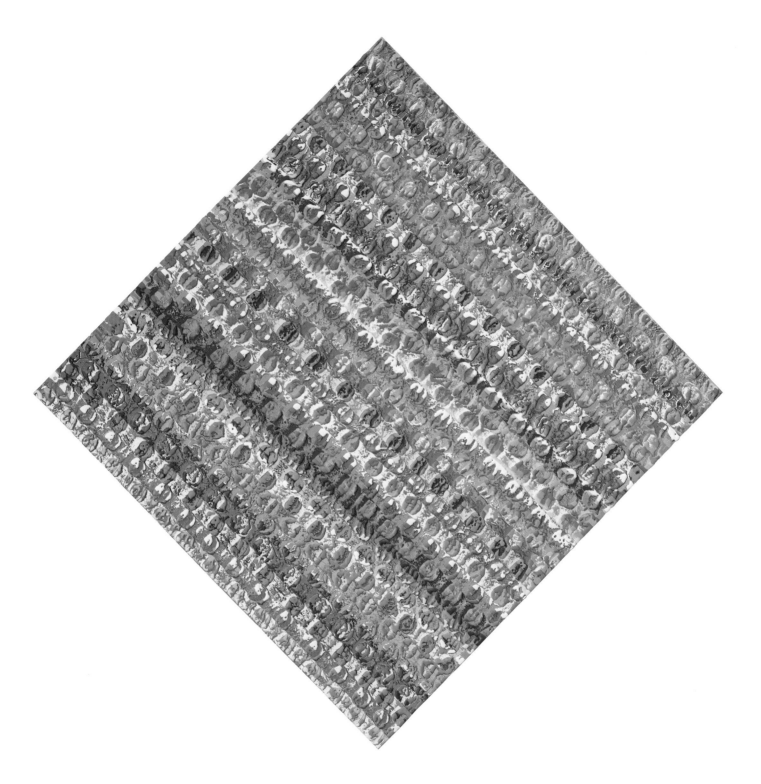

Aladdin, 2009

Gupta, 2010

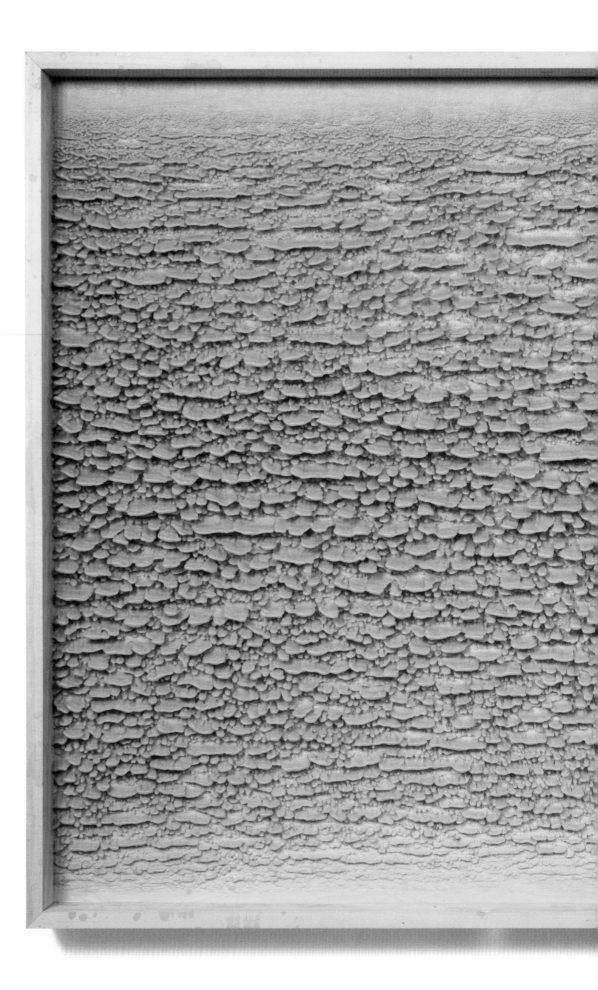

Romantic Nature, 2010

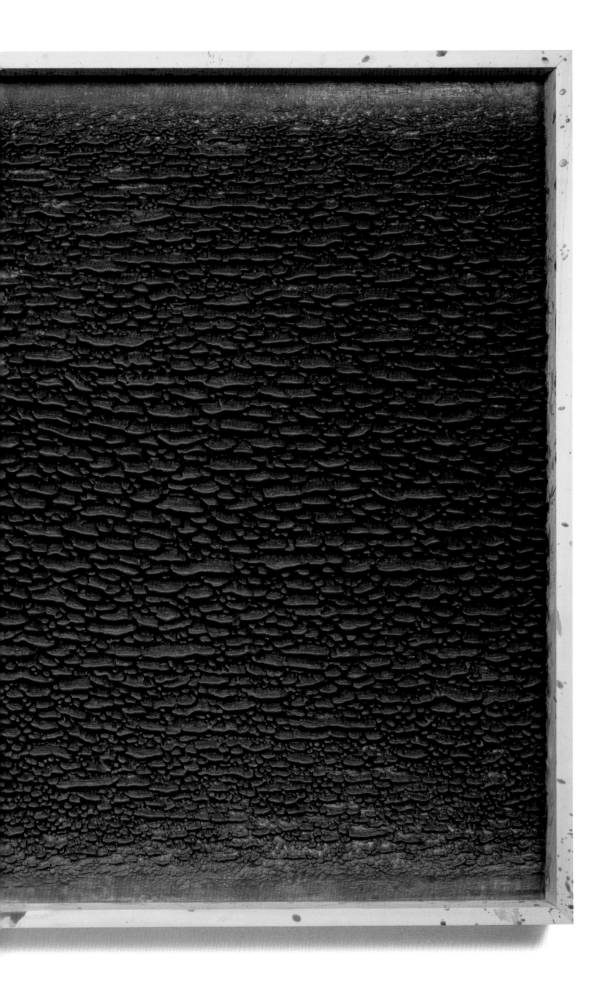

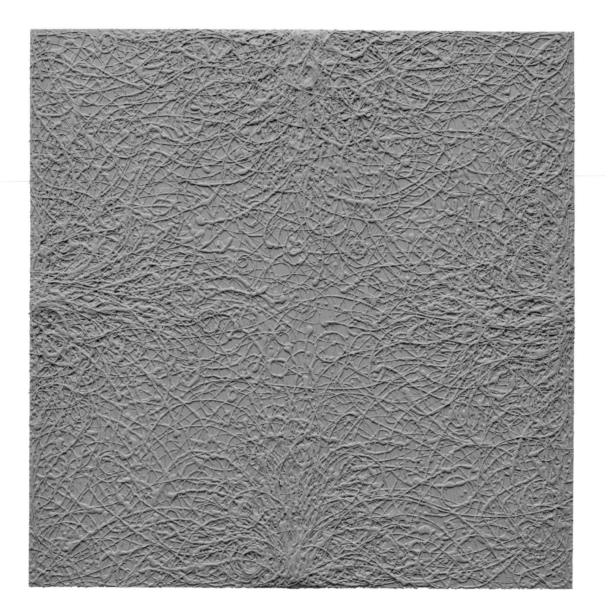

Grey Turf, 2010

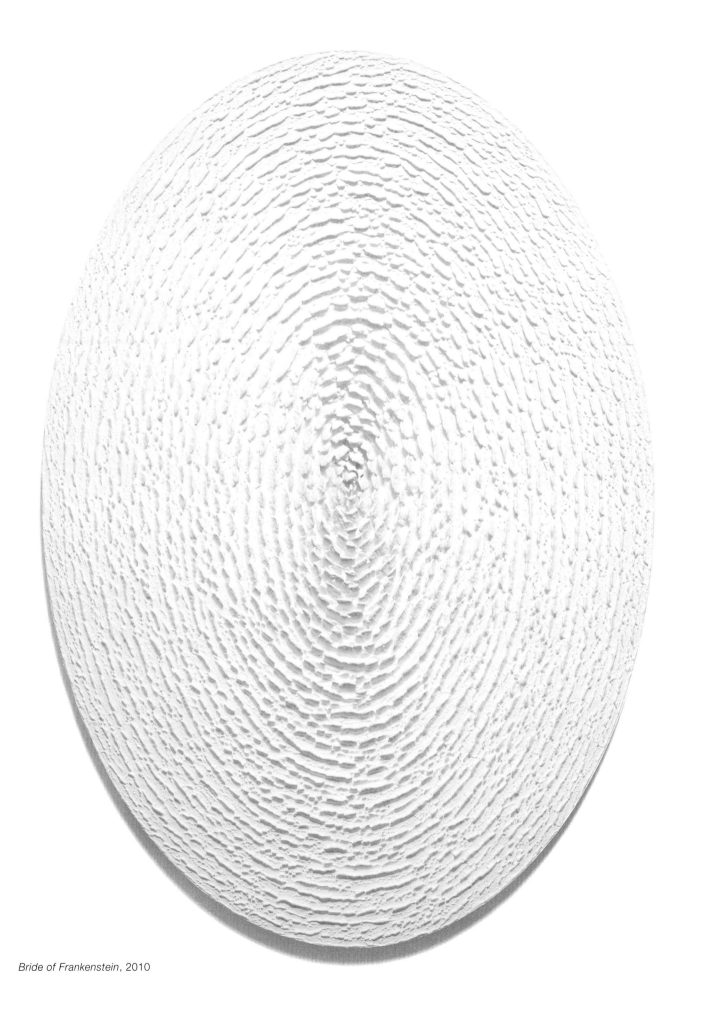

Bride of Frankenstein, 2010

Waking Dream for Kurosawa, 2011

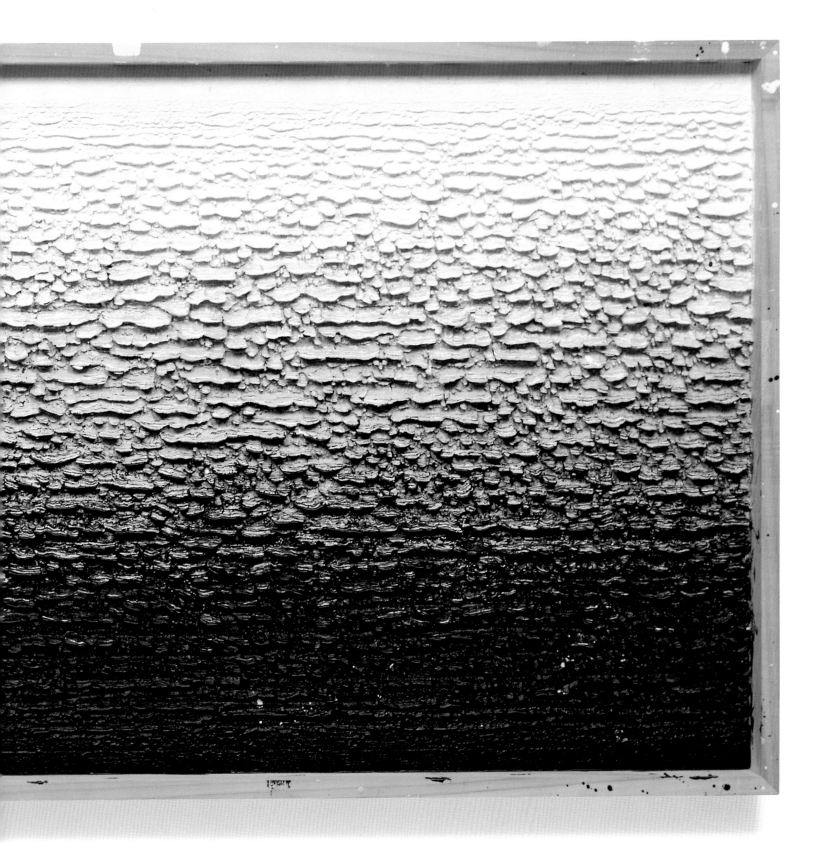

NEXT PAGE *Painting Sculpture,* 1999 and 2009

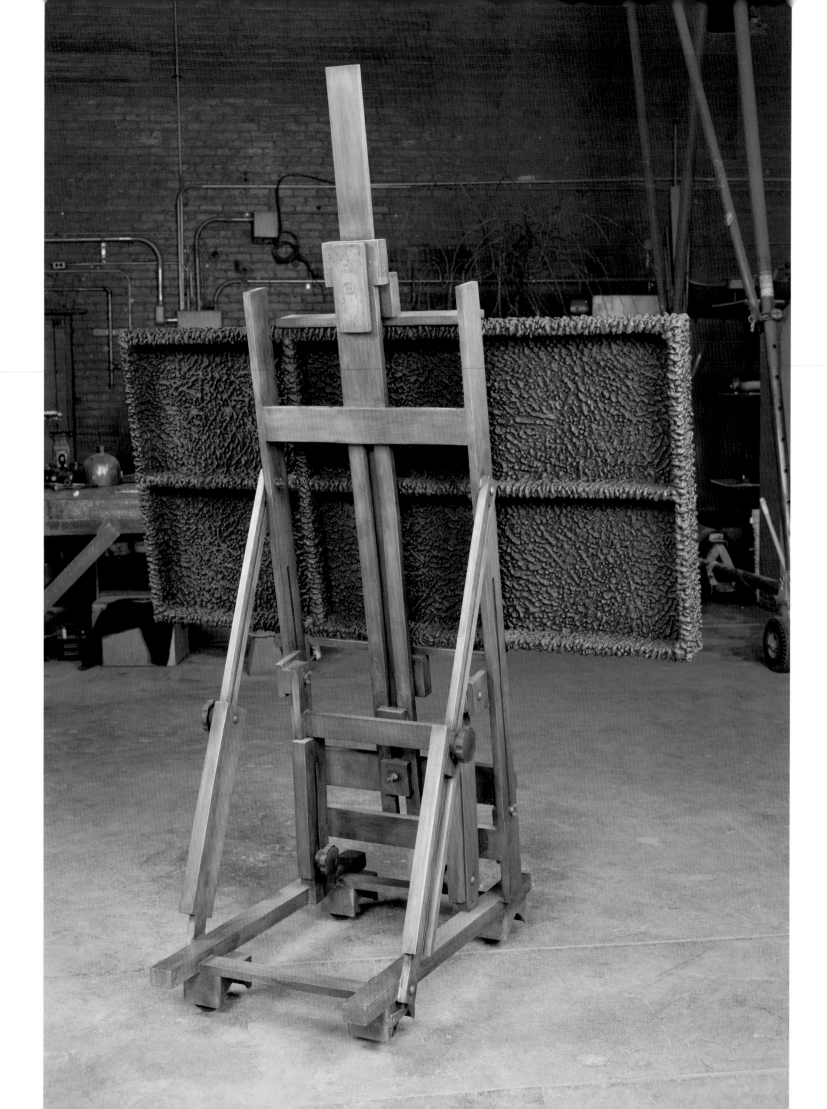

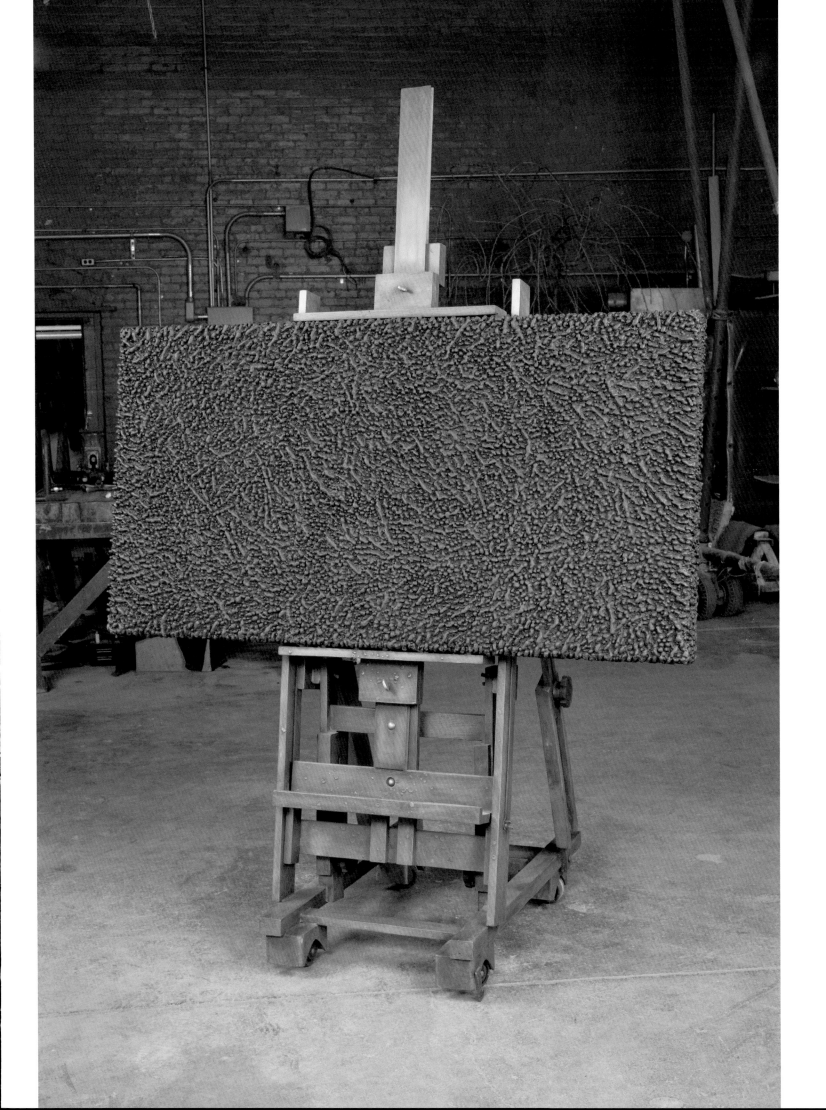

List of Works

60 *Phenomenon,* 2000
encaustic on panel
62 x 49 x 3 inches
(157.5 x 124.5 x 7.7 cm)

61 *Catholic Theme,* 2002
encaustic on panel
17 x 17 x 5 inches
(43.2 x 43.2 x 12.7 cm)

62 *Carbon Specimen*, 2004
carbon steel (unique cast)
113 x 12 x 12 inches
(287 x 30.5 x 30.5 cm)

63 *Pair of Drums,* 2002
bronze (unique casts)
left: 16 x 17½ x 17½ inches
(40.6 x 44.5 x 44.5 cm)
right: 16½ x 17¾ x 17¾ inches
(41.9 x 45.1 x 45.1 cm)

65 *Journal Entry,* 2001
stainless steel (unique cast)
26⅛ x 32⅛ x 1¾ inches
(66.4 x 81.6 x 4.4 cm)

66 *Van Gogh,* 2001
encaustic on 19ᵗʰ century
wood and rush chair
34½ x 18¾ x 15½ inches
(87.6 x 47.6 x 39.4 cm)

67 Scholars table with 13 objects
Left to right:

Sage, 2010
wax on wood
13¼ x 5 x 3 inches
(34.9 x 12.7 x 7.6 cm)

Imperial box, 2003
bronze (unique cast)
12½ x 12 x 12 inches
(31.8 x 30.5 x 30.5 cm)

Banzai!, 2008
encaustic on wooden bowl
3¼ x 6½ x 6½ inches
(8.3 x 16.5 x 16.5 cm)

Model for Painting Sculpture, 2010
encaustic on panel
on wood easel
15¼ x 6 x 6¼ inches
(38.7 x 15.2 x 15.9 cm)

Scholars Rock, 2007
bronze (unique cast)
15½ x 5 x 4½ inches
(39.4 x 12.7 x 11.4 cm)

Little View for the Scholar, 2001
bronze (unique cast)
8 x 6⅝ x 2 inches
(20.3 x 16.8 x 5.1 cm)

Yayoi (#4), 2006
beeswax on wood
34 x 8 x 11 inches
(86.4 x 20.3 x 27.9 cm)

Martin's Sushi Special, 2006
bronze (unique cast)
3 x 4 x 7 inches
(7.6 x 10.2 x 17.8 cm)

Emperor, 2002
bronze (unique cast)
11½ x 5½ x 5½ inches
(including base)
(29.2 x 14 x 14 cm)

Torso, 2001
encaustic on wood
14½ x 16½ x 9 inches
(36.8 x 41.9 x 22.9 cm)

Personnage, 2000
bronze (unique cast)
31½ x 12 x 13 inches
(80 x 30.5 x 33 cm)

Imperial box, 2003
bronze (unique cast)
12½ x 12 x 12 inches
(31.8 x 30.5 x 30.5 cm)

MOT, 2001
white bronze (unique cast)
8 x 8 x 5 inches
(20.3 x 20.3 x 12.7 cm)

68 *Cast Drawing*, 2001
bronze (unique cast)
26⅛ x 32⅛ x 1¾ inches
(66.4 x 81.6 x 4.4 cm)

69 *King*, 2000
bronze (unique cast)
13½ x 20 x 12 inches
(34.3 x 50.8 x 30.5 cm)

69 *Consort*, 2000
bronze (unique cast)
12½ x 21½ x 11 inches
(31.8 x 54.6 x 27.9 cm)

70 *Empoisonner*, 2001 and 2007
encaustic on panel
62 x 49 x 4 inches
(157.5 x 124.5 x 10.2 cm)

71 *Great Expectations*, 2002
encaustic on panel
96 x 48 x 5 inches
(243.8 x 121.9 x 12.7 cm)

72 *Stainless Bowl*, 2003
stainless steel
5½ x 19¾ x 19¾ inches
(14 x 50.2 x 50.2 cm)

73 *Axis Mundi,* 2002
beeswax on cedar
120 x 60 x 60 inches
(304.8 x 152.4 x 152.4 cm)

74 *Torso,* 2002
bronze (unique cast)
50¼ x 22 x 14 inches
(127.6 x 55.9 x 35.6 cm)

75 *Eakins*
(for Leo Steinberg), 2002
bronze (unique cast)
79 x 23 x 23 inches
(200.7 x 58.4 x 58.4 cm)

76 *Jackie Robinson*, 2005
wood baseball bat, copper, iron,
steel and bronze nails
32¾ x 8½ x 8½ inches
(83.2 x 21.6 x 21.6 cm)

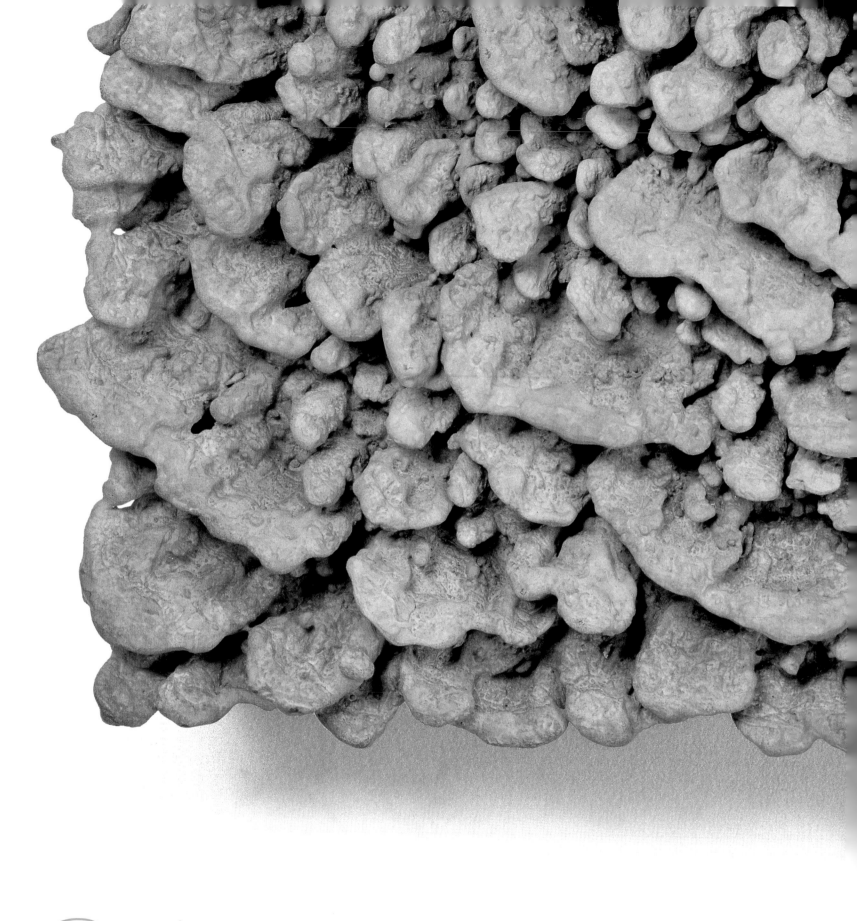

Selected Essays

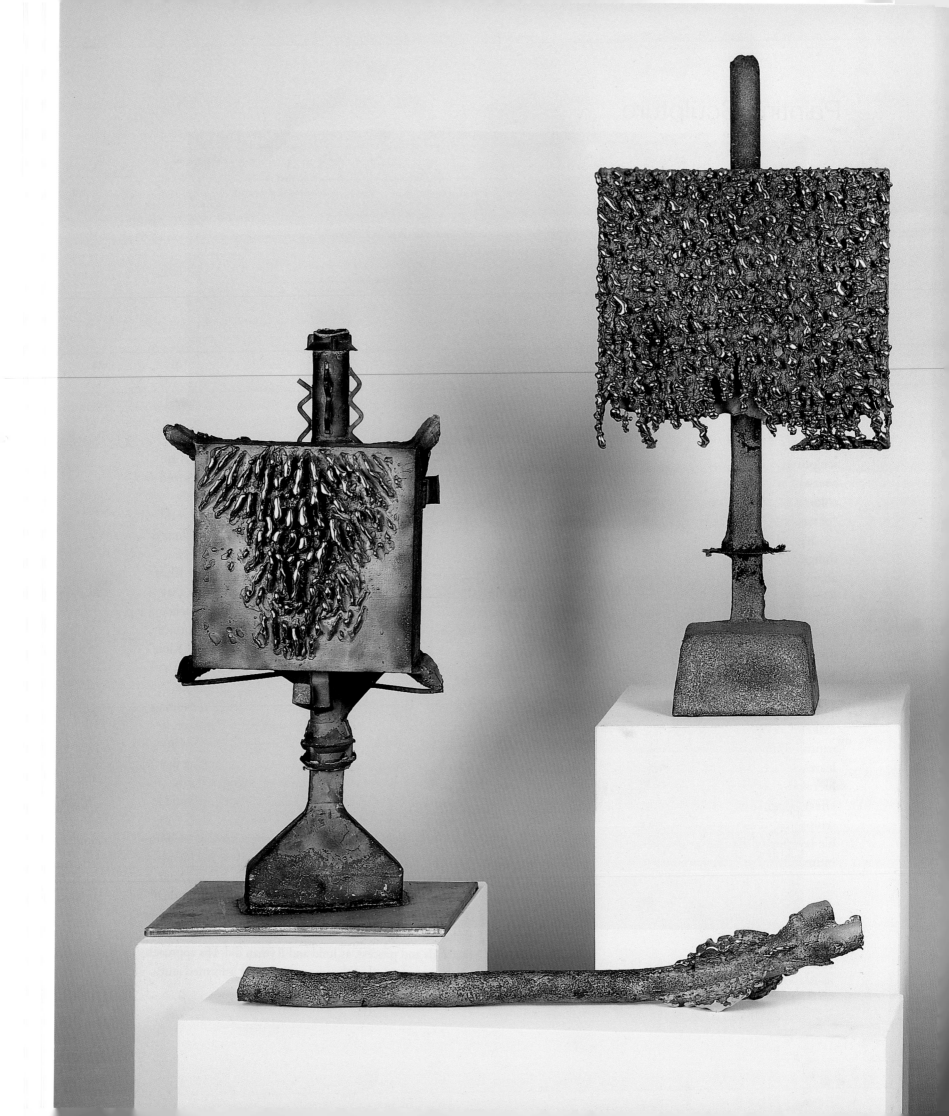

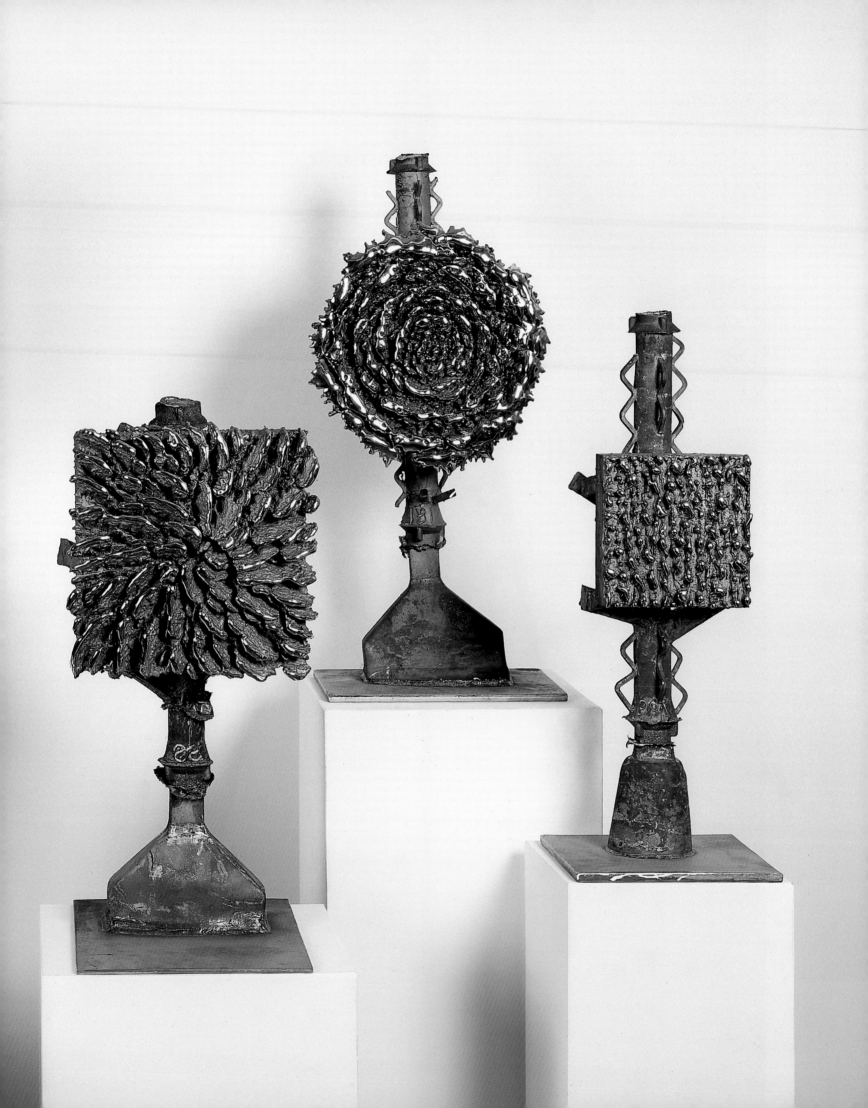

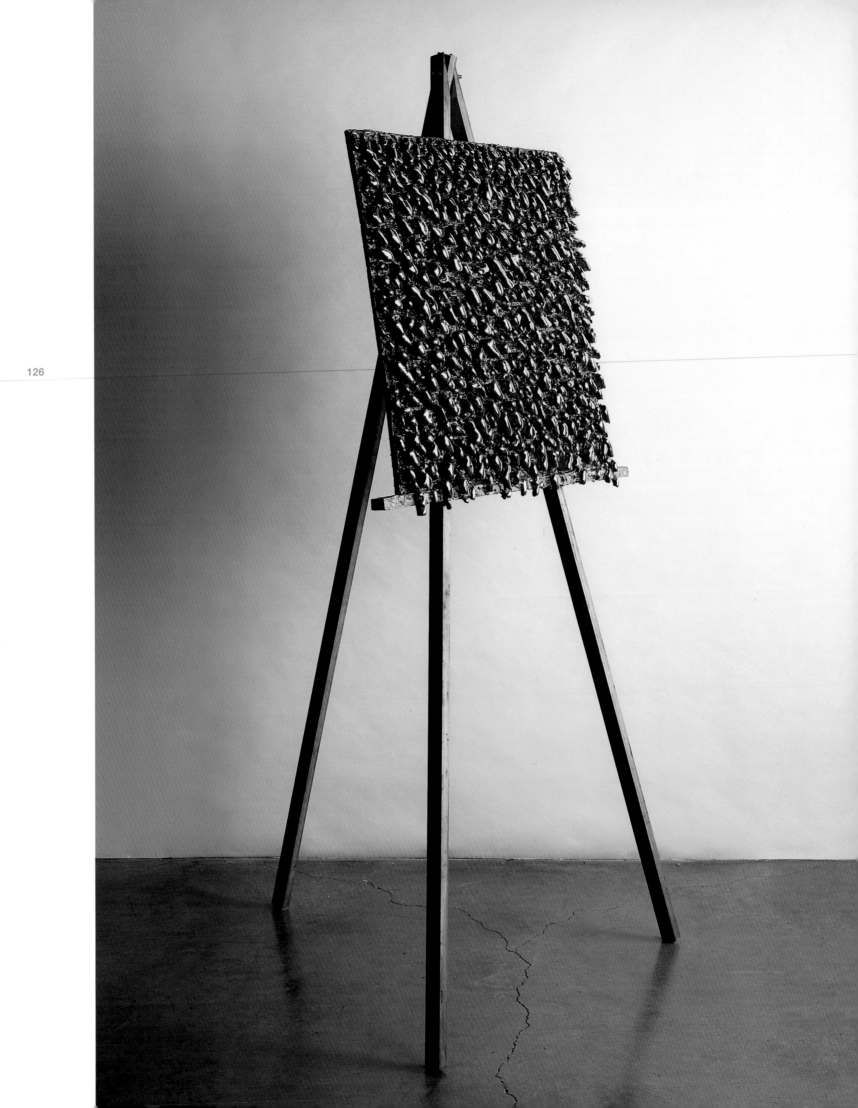

Where Ryman might employ a newly minted, technical composition board designed for architectural model-making, and mimic the layers entailed in its fabrication in the way he lays his paint down, Kline salvages a section from the trunk of a cherry tree. Back in the studio, in his own words, he "coats its roof with shingles" of chartreuse green wax. The conspicuously chemical pigment of the wax clashes violently with the subdued natural browns and beiges of bark and wood. The application of the wax builds on the horizontal saw-blade ridges. The difference between Ryman and Kline is two-fold: the wide range of "supports" that Kline subjects to his painterly process, from tree stumps and limbs, an art crate, a suitcase, a book, or a chair; and his desire to place his practice within the brackets of traditional Western art media—hence, "Painting Sculpture."

Kline does not belabor matters of content, although they exist. The underlying identity of the support, the "treeness" of the tree stump or the "easelness" of a cast easel, is important—not just as armature and structure, but also as the evidence of a history appropriated and enhanced and, above all, preserved.

Kline's method is one of immediate, self-imposed assignments, a mix of meticulous process and serendipitous discovery, though in reverse order. The painted found objects are the most conspicuously associative. However, the spectrum of works ranges from the almost ethereally

dematerialized circular mandala-like paintings shown in some of Kline's earlier exhibitions to the totemic, cipher-like abstractions of recent carbon steel cast sculptures. Kline's use of color is equally spectacular in its variety and calibrated in its application.

Kline's prolificacy has something in common with what a friend of Eva Hesse once observed about her working method: that cutting bits of rubber tubing is her "small talk." There is a similar sense of making that includes the appropriation of objects from his daily life and environment. What links his various practices is the commitment to make every aspect of his process apparent—thinking made visible as material trace. It is tempting to regard the whole studio as an exhibition object. One thinks of the requisite photos included in artist catalogues of studios, work tables, and crowded walls. But the demands of the white cube are equally strong. It forces Kline to pare down the proliferation, to single out isolated objects for contemplation and to sort out the threads of his practice. This seems especially relevant with reference to his paintings, the most abstract of his works.

In the gallery, the sense of fecundity and *horror vacuii* that permeates the studio is held at bay. The visible patterns and material increments entailed in the application of wax to panel vanish temporarily, yielding a more overall, almost dematerialized impression. Instead, the subtlety and range of Kline's palette suddenly looms large: one becomes acutely attuned to the radically different impact of an artificial Day-Glo pink and a corporeally pungent blood-red, or the more subtle distinctions between a white-white and the uncolored yellow-beige of the beeswax or luminous metallic silver. In this context, the cast sculptures seem closer to the paintings than to the found objects that have been literally painted in wax. Like the paintings, the sculptures are colored matter. Carbon steel, bronze, and stainless steel are treated less as distinct metallic compounds than as subtly differentiated colors on a metallic palette. Kline is specific about this interest. Asked to describe the various metals he has used, he replied:

Bronze—one has the option of color in the choice of patina, where there is a large but limited range to choose from.

Carbon steel—rusts and seems related to the earth; there is something raw about it, and by and large it is monochromatic and its surface is matte.

Stainless steel—like working with black and white. Polished surfaces reflect existing light. There is a strong contrast in the textures of the metal, between the satin

gray and the polished smooth surfaces. The surface seduces in the way that precious metals do.

White bronze—a nickel-colored steel, which cannot be patinated and has a precious quality like silver.

Over the past thirty years, the semblance of a central discourse around which the cutting-edge art world seemed to orient itself has steadily diffused to the point that a recent reviewer of a critically acclaimed group show in Chelsea could credibly argue that each of the exhibitors came off as "Outsider" artists. Their work is "fanatically crafted but conceptually out there, beyond the fringe."[2] From an academic perspective, the absence of a central discourse can be frustrating. It makes it harder to pinpoint development and to identify critical criteria. In many ways, the apparently idiosyncratic range of art being made now forces us to develop other criteria for understanding and evaluation.

Today there is little evidence of any convincing effort by artists to develop broad theoretical positions, such as Donald Judd's notion of "Specific Objects." Rather, the diversity and subjectivity that characterizes the current art world seems closer to that of the exploratory moments of the early 70s than of the early 60s, but with an important distinction. While much art today is intensely private and idiosyncratically expressive, the expression itself seems indirect, unlike the pluralistic explorations of identity and practices that characterized the 70s. It is almost as if today's younger artists are "channeling" everything from image to experience, functioning sometimes in a quasi-mystical way as mediums themselves. In judging the art we view these days, we seem to be looking for two things especially: the capacity to offer up a convincing experience—aesthetic, sexual, sensual, political, representational, etc.—and/or a visible methodology, in which drawing, painting, picturing or assembling impresses technically or dazzles through its craft.

Kline's work does both. Combining a revisionist investigation of such traditional practices as encaustic painting and lost-wax casting with his own conceptual investigation, which conflates the directness of drawing with the expressive possibilities of painting, he generates an oeuvre with its own urgent, internal logic.

What persists in Kline's art in the move from studio to gallery is the tense tug-of-war he has staged between armature and affect, or between the visible structure of his manipulated wax and the inherent expressivity of the worldly and natural forms he appropriates. The contrast between two large treated wood objects—a tree stump and a wooden beam—offers the clearest example. On each he has built up

the wax to convey a distinct and underlying structural configuration: entropic circular strokes indicate the tree's natural growth, and perhaps an unnatural amputation, with wax oozing down its sides like sap or blood; vertical and horizontal constructive strokes on the beam signal its functional conversion of tree to lumber. *Axis Mundi*, or center of the world, is the title Kline gives the beam. The world, our world, the title seems to say, is built upon the processed beam, and not the rooted, growing tree; yet Kline treats both as others have treated a city wall or subway door, as ripe for appropriation. The graffiti artist imposes his signature indiscriminately on any available surface, and Postminimalist painter expresses material structure by banishing subjective reference, but Kline suggests a different paradigm. Structure, he seems to be saying, cannot be divorced from the psychological and emotional associations we bring to it. His mission is to amplify the complexity of the forms he finds: a dream of clear form in days of muddled thought.

Cambridge, Massachusetts

1 Barbara Rose, "A Conversation with Barbara Rose," *Martin Kline: New Works*, exh. cat. (New York: Marlborough Gallery, 2000), p. 5.

2 Holland Cotter, "Something, Anything," *The New York Times*, July 19, 2002, p. B34, reviewing the summer group exhibition curated by Naland Blake at the Matthew Marks Gallery, New York.

Möbel Transport, 2001
encaustic on wood crate
37½ × 33 × 8¼ inches
(95.3 × 83.8 × 21 cm)
Norma B. Marin Collection

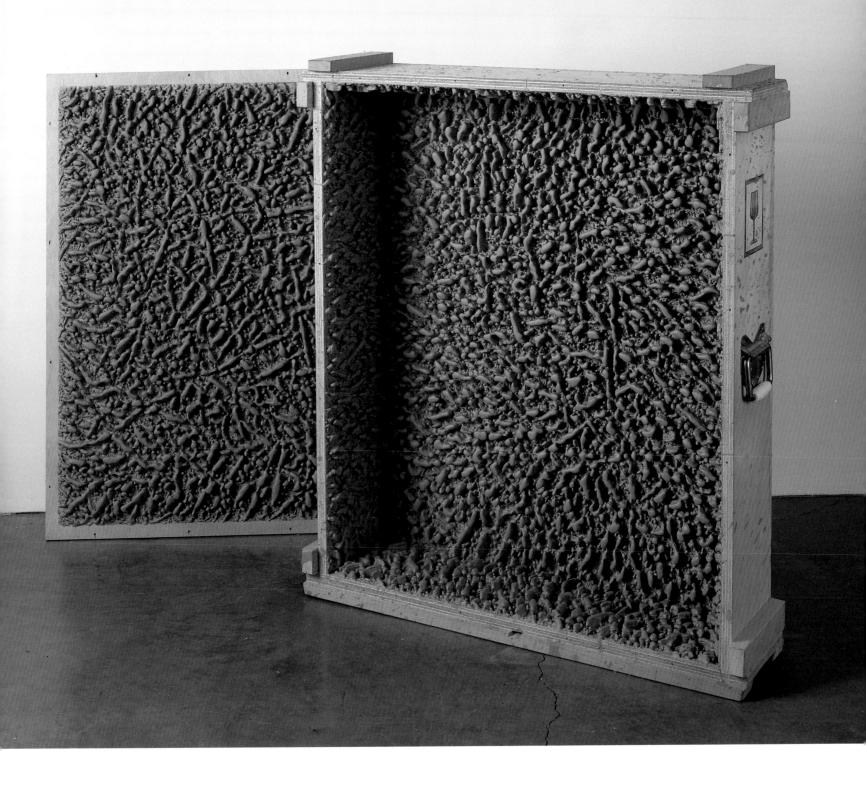

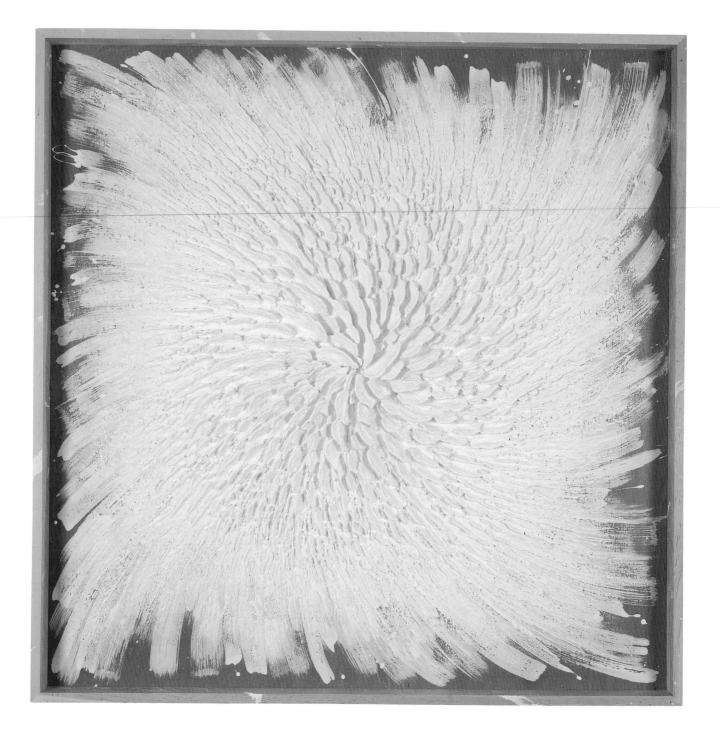

Truth Awakens as Fiction: The Art of Martin Kline

CARTER RATCLIFF 2005

Martin Kline's *Leda*, 2002, is a curvilinear pattern in a square frame. The painting's energies flow from the center in graceful, nested arcs, of built-up paint. Moving at first with sensuous deliberation, the ridges slim down as they go, as if they were accelerating. By the time the paint reaches the peripheries it displays a feathery delicacy. That *Leda* is not only feathery but white is fitting, in a roundabout way, for we always recall the mythological character named Leda in the company of the swan who turned out to be Zeus in disguise. Holding on to the image of a bird, we might see wings in the pattern that circles midpoint of the painting. When that image gets away, we could see the pattern as floral or even sexual. Leda, after all, was the object of Zeus's violent love. Metaphors stir up possible meanings. What is certain is the presence of paint.

Kline works in encaustic, which is pigmented wax. Liquefied by heat, it goes on in layers that can never quite hide one another. The crucial contrast is with oil paint, which allows one hue to render another hue completely invisible. "I always disliked that about oil painting," says Kline. "I want to show everything." Moving a loaded brush over a wood panel, he encourages the paint to accrue in ways that are impossible to describe in any detail but thoroughly intelligible to the eye. You see where minute irregularities in the first brushstrokes caught more than their share of paint from subsequent brushstrokes and, layer by layer, acquired discrete shapes. A painting is the outcome of the additive process.

Leda, 2002
encaustic on panel
49 × 49 × 4 inches
(124.5 × 124.5 × 10.2 cm)
High Museum of Art
Gift of Kathy and Billy Rayner, 2006.30

Determined to hide nothing, Kline makes paintings that show us how they were made. Each is a revelation of its own history. Clearly, *Leda* was painted with a gesture that followed, time and again, a certain curve. You can't see the painting without seeing that. Moreover, it is self-evident that Kline loaded his brush with just the right amount of paint to effect the transition from thick ridges near the center to thin layering at the edges. Adjusting the load for *Blue Heart*, 2000, he made this contrast even greater than it is in *Leda*. Square frames surround but do not inflect the curvilinear patterns of *Blue Heart* and *Leda*. Relations between curves and right angles are not so stand-offish in *Lucy in the Sky*, 2001. Here, a central pattern of rounded ridges mixes with the colors, if not the squared-away forms, of the underlying grid. The ridges of *Mirage*, 1999, and *Light in August*, 2001, run along straight lines, and there are further variations—the dense tangle of *Real McCoy*, 1998, for instance, and the grid of *Fruitcake*, 1997, which is overwhelmed and in places obscured by the colors its compartments cannot entirely contain.

Though the strangeness and subtlety of the forms in Kline's paintings can be startling, there is no mystery in his process. Again, encaustic is forthright, in contrast to oil paint, which Kline sees as duplicitous. His use of the encaustic medium meets a standard at once aesthetic and ethical: a successful painting or sculpture presents, first of all, the truth about its constituent materials, and then the truth about the process by which those materials acquired the forms we see. Originally promulgated by the Minimalists—in particular, Robert Morris, Donald Judd, and early Frank Stella—this evidentiary ideal has been extraordinarily powerful.

Minimalism's idea about the truth of art stands opposed to the commonsense assumption that artists intend to make some comment, presumably true, about something other

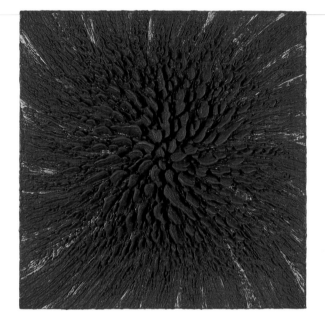

Blue Heart, 2000
encaustic on panel
25 × 25 × 6 inches
(63 x 63 x 15 cm)
Collection Triton Foundation, Belgium

than their works. In his *Lectures on Aesthetics*, delivered in the 1820s, Hegel converted common sense into the grandly metaphysical claim that, liberated from mundane uses, art becomes "a mode of revealing to consciousness and bringing to utterance the Divine Nature, the deepest interests of humanity, and the most comprehensive truths of the mind." Variations on Hegel tend to miniaturize him by focusing on one sort of truth: emotional, cognitive, political, or whatever. Minimalism, some have said, narrows the focus to the work itself or in one of Morris's manifestos, to the gallery space where the work appears. But this account overlooks a crucial difference between Minimalism and all the art that preceded it.

That earlier art referred to the world, obviously or subtly. Even the "pure" art of the color-field painters brings to mind, however obliquely, qualities of light and immensities of space. No such referential paths connect a Minimalist object to the work beyond the studio and the gallery—not, anyway, if we take the object on its own terms. We are to see the object, the whole object, and nothing but the object, and this exclusionary focus became even more intense as the object dissolved into the heaps and scatterings and drifts of process art by Barry Le Va, the post-minimalist Robert Morris, and many others. This is where Martin Kline comes in, for I am arguing that his concern for self-evident truth shows in his painterly processes, which produce results not only compelling—there is no end to following the intricacies of his forms—but self-explanatory. One has to say more, however, talk of truth can never be adequate to art. Artworks are also fictions, and Kline's fictions are especially rich.

Though his fictions originate in truths with the flavor of Minimalism and process art, I ought to note that he cannot be considered a fan of Minimalism. He recently said that it has "elements I connect with—the reduction of forms, simplicity, and economy." Nonetheless, he is 'not wildly crazy" about Minimalist art even at its best because it "lacks even a suggestion of representation." Kline feels a much closer connection to the less reductive art of "Brancusi, Pollock, Mondrian, Kelly, and even late Matisse." Yet his works owe their hyper-palpable presence to an idea of truth that simply wasn't available to artists until Minimalism put itself on the map of aesthetic possibility.

Reinventing this possibility for himself, Kline arrives at forms that have the power in themselves to absorb the attention: the sensuous flanges of *Leda*, for example, or of *Light in August*. These paintings make the plain truths of sheer pigment seem sufficient. Yet *Leda* also generates allusions to wings and myth, and *Light in August* suggests

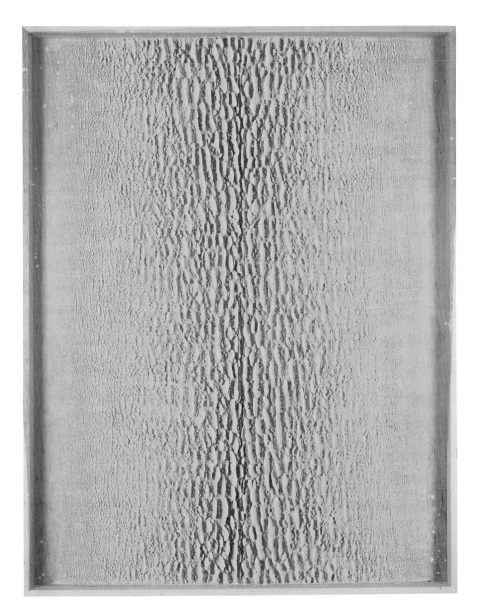

Light in August, 2001
encaustic on panel
62 × 49 × 4 inches
(157.5 × 124.5 × 10.2 cm)
Brooklyn Museum, 2005.57
Purchased with funds given
by an anonymous donor

everything from layered clouds to a river bottom scored by currents of water. *L'Atelier,* 2003, suggests that Kline is aware of his originality, for this unique bronze casting of a traditional palette bears, along with his initials, several samples of his characteristic forms. This is a sculpture that functions, in part, as a slightly ironic calling card. In working out the relations of truth and fiction in Kline's art, I found myself thinking about a recurrent theme in eighteenth-century painting: Truth Unveiled by Time. According to Tiepolo, Batoni, and others, Truth is a young woman and Time is the aged man who undresses her with reverence and, one supposes, no haste whatsoever. The idea seems to be that Truth, hidden by the errors and dishonesty of

ordinary life, becomes visible only after who knows how many millennia have crept by. Truth will not be aged by the passage of all those years because she lives in a transcendent realm beyond the reach of ordinary time. Kline's truths appear *through* time or, one might say, in the course of a long embrace or temporality. His truths are not eternal but contingent and his works fascinate—literally—because they make the contingencies of his process so explicit. Their surfaces attract and hold the gaze the way an intricate drift of snow or a pattern of erosion sometimes does.

Not that anyone would ever take Kline's shapes and voids for natural phenomena. Alive with intention, the surfaces of his paintings emerge from circles and various

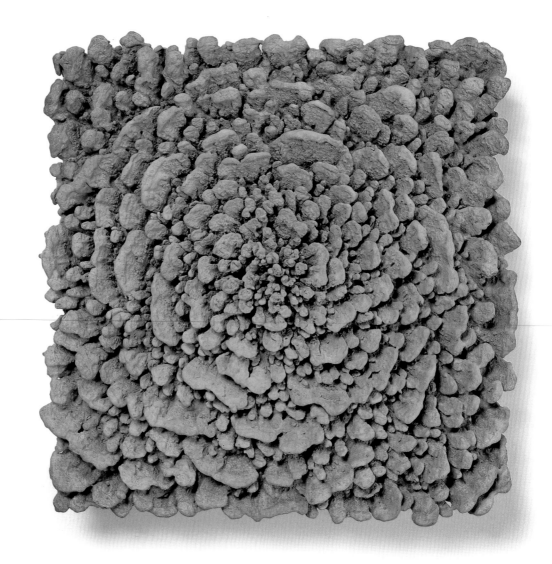

Cast Painting, 1999
bronze (unique cast)
13½ × 13½ × 2¼ inches
(34.3 × 34.3 × 5.7 cm)
Collection of Tom McWilliams

linear patters: forms that signal, with minimum fuss, a human purpose. To begin, he establishes one of these basic formal premises. Next, he decides what sort of brushstroke to make, over and over, and how to respond to the variations that inevitably occur. I imagine him working in a hyper-concentrated trance. I am not saying that as he paints, he never, at any point, imagines that the finished painting might allude to something other than itself. But I am saying that, to give his forms their self-evidentiary power, he must suspend his imagination and concentrate on sheer process. This is what I mean by his trance. Coming out of it, he disengages from his materials and sees the metaphorical implications of his forms—or, to shift the focus from artist to artwork, Truth Awakens as Fiction.

Whatever we read into his painting, Kline remains an abstractionist. Given that abstract art has always been meta-phorical, one might ask how his metaphors are different from those of Mondrian, for example. The difference is in their relation to their place of origin, the tangible work of art.

Mondrian wanted us to see his precisely balanced austerities as intimations of a just and harmonious social order. To do that, we must look with metaphorical vision far beyond the canvas. To feel the force of Kline's metaphors, we have to concentrate on his forms as sumptuously layered configurations of matter. His fictions preserve strong ties to his truths. The imaginary stays in close touch with the physical, and so the imagination awakened to Kline's metaphors is haunted by a sense of the artist's entrancement, his captivation by his materials, as the day-lit mind might be tinged by a dream.

Explicit or subliminal, this emphasis on the material presence of the artwork has been pervasive in the wake of Minimalism. It appears in the textures of Robert Ryman's paintings, and we see it again whenever Ellsworth Kelly transposes one of his characteristic shapes from a high-keyed canvas to a slab of wood or metal. This latter-day physicality is aggressive in Elizabeth Murray's more extravagant works, yet it can be just as insistent when it is unassuming, as in Richard Tuttle's dyed cloths. Martin Kline became an artist

Night Time Enigma, 2000
encaustic on panel
42 × 32 × 4 inches
(106.6 × 81.3 × 10.2 cm)
Collection of Mr. & Mrs. Laurans Mendelson

at a time when, for so many, an image is persuasive only if it has substance in some literal sense of the word. Of course, many artists still try to induce matter to deny itself. Kline looks for ways for matter to be more undeniably material. Thus, *Cast Painting*, 1999, is an already weighty work remade in bronze. Yet it is just as floral—just as metaphorical—as *Leda* or *Blue Heart*.

Impatient with the Minimalist ban on representation, Kline endows his works with all sorts of imagistic powers. His allusions to flowers and lichen jump off the wall, and the lustrous black rows of *Night Time Enigma*, 2000, bring vividly to mind the fungi known as tree ears. Metaphors like these owe some sense of their immediacy to a life-like scale. Tree ears are often the size of the forms that Kline's brush built up on the surface of *Night Time Enigma*. When the scale shifts, allusions turn elusive. At first, the accumulation of white paint on the wood block of *Oath*, 2001, looks like sheer matter. Sooner or later, though, it acquires the geological scale of a maze of canyons in a polar landscape. Acknowledging the allover fields of Jackson Pollock and the encaustic of Jasper Johns, *Jackson Johns*, 1998, has the scale of art history. Like *Real McCoy* and Kline's other field paintings,

it evokes, as well, the sub-molecular patterns registered by cloud chambers.

Whatever their size, Kline's works maintain their physicality, but not for its own sake. Nor, as absorbing as it is to figure out his painterly processes in all their variety, does he present process as an end in itself. Like his vividly present forms, the painterly methods that produce them can be understood as arguments by example for attending to the here and now. This is an anti-Hegelian—more generally, an anti-metaphysical—argument to the effect that meaning is not to be found elsewhere, in some transcendent region. It is to be found in the immediacies of perception and in the images and allusions, the evocations and invocations, we spin out of those immediacies. Unlike the Minimalists, who were the first to wrench art history from the grip of metaphysics, Kline excludes neither the imagination nor spirituality.

Icon, 2001, is an iconic instance of Klinean specificity, in part because its surface resists categorization. The moment you say the surface is covered by a pattern of ridges, it begins to look textured. Yet the ridges are too distinct to blend and blur as one expects the elements of texture to do. These remarks may sound like quibbles, yet they point to subtleties of form that, in turn, point far beyond the routines of definition. For if we pay attention to the experience of looking at this work and coming to terms with its precisely balanced qualities, we will not merely settle a question about pattern or texture. Leaving that question behind, we will find ourselves persuaded to have become conscious, intuitively, of what it is to endow an object with meaning. So *Icon* can also be seen as an altar dedicated to the hope that we can come alive to our experience, whatever that may be for any one of us. That the work, originally paint on wood, has been cast in brass, suggests that this hope is permanent. It is among the virtues of Kline's art that it sends us to the far reaches of metaphorical possibility. A complementary virtue is that it returns us to our own responsibility for making sense of what we see.

Statements by the artist are from a conversation
and an email exchange with the author in August of 2005

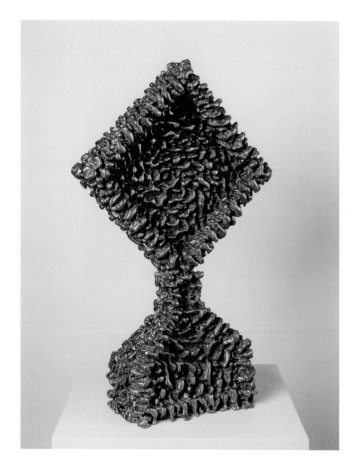

Icon, 2001
brass (unique cast)
23 × 15 × 6 inches
(58.4 × 38.1 × 15.2 cm)
Dr. John O'Neal and Jean Carlyn

Lucy in the Sky, 2001
Encaustic on panel
62 × 49 × 2¾ inches
(157.5 × 124.5 × 7 cm)
Collection Triton Foundation, Belgium

Made in Japan

MARTIN KLINE 2006

In the spring of 2005 I was awarded a grant to live and work in Miyakonojo City, on Japan's southernmost island of Kyushu. The works in this exhibition were made there in April, May, and June of that year. A requirement of the grant was residency for a minimum of three months. I found myself in the uncomfortable position of wanting and not wanting to go, as this distant and lengthy trip would offer discovery but also discomfort. Accepting this challenge would mean familiar hearth, home, and activities would be postponed and replaced with a great unknown, as one previous visit to Japan did not and could not prepare me to live there. Thus, I left New York to dwell in the land of square bathtubs, driving on the right side of the car and the wrong side of the road, endless bowing and gift-giving, smiling children on bicycles, infinite varieties of rice, chicken and horse sashimi, green tea, and the countryside, where virtually all plant life, from forest to farm, is intensively cultivated and controlled. It is commonly said that if you wish to see the real Japan, skip the cities and go to the countryside.

I visited Tokyo, and the ancient cities of Kyoto and Nara at the beginning of my stay, but it was Miyakonojo—semi-tropical, agricultural, and remote—where I lived and worked. There I had little contact with the Western world. Without a single English language newspaper or magazine to be found, I had only CNN and BBC to deliver news of the Papal funeral, Michael Jackson's second trial, and Larry King's interview with Jane Fonda. But even with

Language, 2005
Oilstick on canvas
46 × 36 × 1 inches (116.8 × 91.4 × 2.5 cm)

telephone and the internet, it was clear that I was not in Kansas anymore, and very much a foreigner in a very foreign land. Immersed in a farming community without a map, both literally and figuratively, I set out to learn what my being there meant, what I would do with my time, and what I was going to make.

The ready-made prepared Japanese canvases I treated like sheets of paper. I had been working with the grid again, making allover abstract surfaces. Various figures were soon "freed" from this ground. Faces and eyes emerged and connections were made, as one suggestion followed another. Forms were made with white space around them and then forms were made with the white space closed in. Figuration became prominent and recognizable, sometimes with—but often without—deliberation. Every day I was reading, looking and considering what Japan had been and what it was now, culturally and socially. Each day spent in Japan compounded elements and experiences that shaped my thoughts. Being especially interested in the ancient world and cultures, I studied Japan's Chinese roots, ancient legends, shrines and religion; Japanese garden design, and Ikebana, and the importance of and control over Nature in general; ancient Jomon and Samurai cultures; Tea Ceremony, calligraphy, lacquer, Noh and Kabuki theater. All of these cultural elements filter through a millennium of Feudalism and isolationism to form Japan's present-day culture. Manga (Japanese comics), the starling family that screeched for food at 5:00 a.m. every morning, the tile rooftops from my studio window, the shaped shrubs that every neighbor obsessively groomed—these were some of the ubiquitous elements that crept into the paintings. The amalgamation of experience and contemplation guided me in some automatic way. It was often later that I identified what was in the painting, what it reminded me of, and what associations it conjured. But

Dream of the Samurai, 2005
oilstick on canvas
46 × 36 × 1 inches (116.8 × 91.4 × 2.5 cm)

Venus of Tokyo, 2005
oilstick on canvas
46 × 36 × 1 inches (116.8 × 91.4 × 2.5 cm)

sometimes there was immediate recognition and that could lead to variations.

Having avoided speech-making my entire life, I found myself giving speeches regularly, to groups of a few and sometimes to hundreds. There were newspaper interviews and appearances on cable television and official meetings with the city's Mayor. Often I was the only *gaijin* (foreigner) in a store or setting, an object of intense staring and curiosity, or sometimes its opposite: totally ignored. Exuberant and joyful schoolchildren were a weekly encounter at a junior high school where I set up a satellite studio to show them what an artist is, and what he does. When I could work no more, the hours spent watching people and shopping at Jusco for groceries, Daimaru Department Store, Hansman Hardware and Uniqlo (the Gap of Japan) were a means of survival and recreation, every encounter utterly fascinating and new.

The simplest activity was magnified and intensified: communication, cooking, using household appliances and buying food with no labels in English, driving a car and making sure that I turned into the correct lane. These things, among so many others, took me back to the childhood practice of learning how things are done by watching others. Even the relaxed environment of the house required new behavior: the constant removal of shoes indoors, sitting on the floor with legs crossed, and sleeping on a futon on a tatami mat. Two prominent and inherent components of Japanese life, formality and protocol, are invariably perplexing to the Westerner. These and the many other rituals filled my days with challenge and reward, exhilaration and exhaustion.

When an artist is at home in his studio invention is voluntary, but when he travels to a new world, invention is compulsory. Unanchored and set to sea the adventure begins. There is wonder, surprise, frustration and uncertainty at every turn. To leave the familiar environment and enter unknown territory simultaneously forced and allowed new perspectives, making an art distinctive and reflective of a particular place and time. This "freedom" from home yielded paintings which were then and are now still, one year later, sometimes foreign even to me.

Rhinebeck, New York

Shogun, 2005
oilstick on canvas
46 × 36 × 1 inches (116.8 × 91.4 × 2.5 cm)

Vive l'argent!

NAN ROSENTHAL 2008

Martin Kline's particular sensitivity to nature is nurtured by living most of the time in the Hudson Valley, a couple of hours north of New York.

Kline happens, like a number of artists (Ben Shahn, Jasper Johns and Joel Shapiro come to mind) to be an excellent and imaginative cook. It is almost impossible for Kline to compose a salad without making it not only delicious, but also beautiful, as if purple chive blossoms were invented by the horticultural gods specifically for his hand.

At Ohio University in Athens, Kline majored in studio art, mainly drawing, sculpture and printmaking. He had a second major in art history prior to the twentieth century, with an emphasis on Italian Renaissance painting. It was not until he moved to New York in the later 1980s that he became attuned to abstract art.

Kline began working serially, yet in close touch with nature, for example with groups of finely detailed drawings of dead zinnias and yucca flowers. The watercolor lines surrounding the blossoms became reductive circles, structured by grids. These watercolor grid compositions grew into large works measuring five by more than three feet, and some were five by ten feet.

He worked flat, from above, his paper support laid on a table. This gave the artist an aerial view of what he was doing as he did it. His command of these large watercolor works have a delicate yet tough finesse. My colleagues and I

acquired one for The Metropolitan Museum of Art's then Department of Twentieth-Century Art in 1996.

Around this time Kline transferred his topographical views from paper to surfaces of canvas, then of wood panel. These first works, still gridded, were painted with black brushstrokes of encaustic, the ancient Ptolemaic medium of pigment bound with wax. Quickly realizing the inherent sculptural properties of wax, Kline began to build up his surfaces and also began to cast paintings and other objects covered in wax into bronze, stainless steel and carbon steel.

Using a wood panel as the support for his paintings, Kline layered hot, colored wax, which he dripped or painted with a paintbrush. The layers of the paint grew into reliefs, some with particular repeating "leaves" that cast deep shadows. Others were made with shallow layers that are difficult to decipher in terms of the method of their making. A work in pure beeswax, with no pigment, appears white. An abstraction of this variety, entitled *Nest*, 2000, also acquired by The Metropolitan, challenges the public to figure out exactly how the relief was built up. It also challenges the curator to display the work so the haptic appeal of such Klines does not tempt viewers into touching the surface.

Since World War II, numerous artists have insisted that art project into the actual space of the viewer instead of creating an illusion of space behind the canvas surface. This concern is pervasive in Martin Kline's work and is

143

Brand, 2007
encaustic on panel
30 × 24⅛ × 2½ inches (76 × 61 × 6 cm)

NEXT PAGE
Cast bronze and stainless steel baseball bats
(all unique casts) from left to right, various sizes:
Native American, 2007; *Fat Man,* 2004;
Blind Justice, 2007; *Peace Offering,* 2007; *FAG,* 2004;
Bling, 2007; *Sterling Reputation,* 2003; *Honor,* 2007

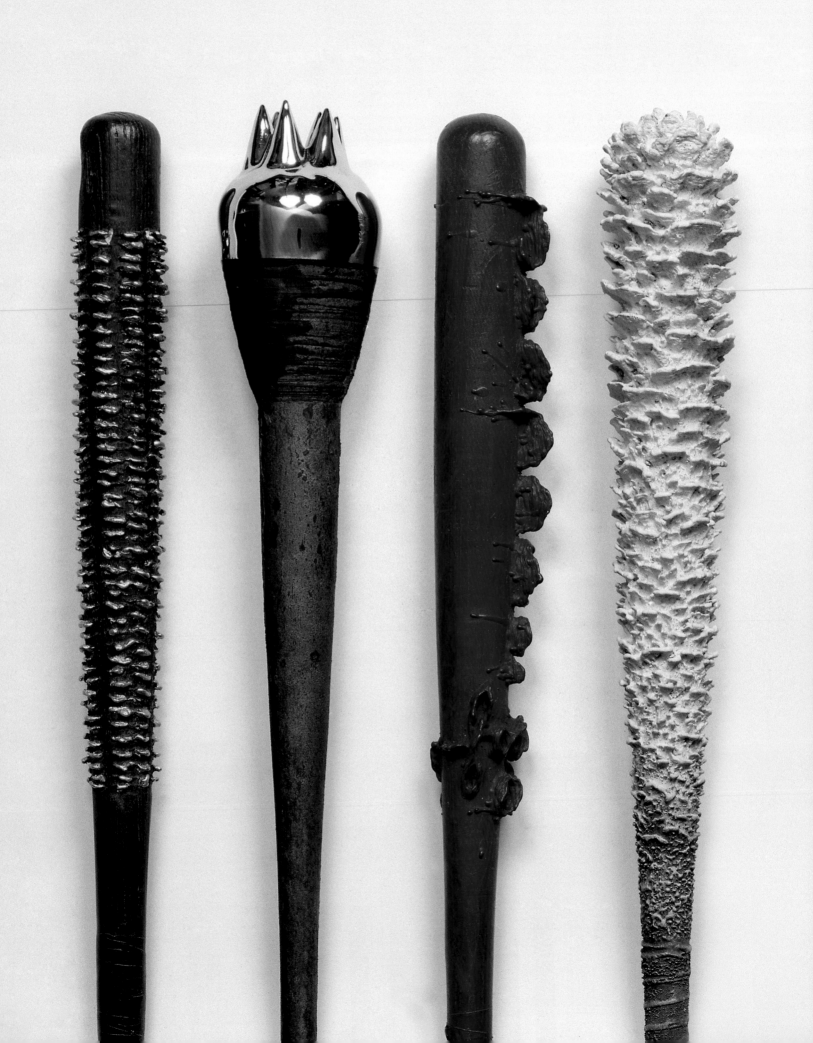

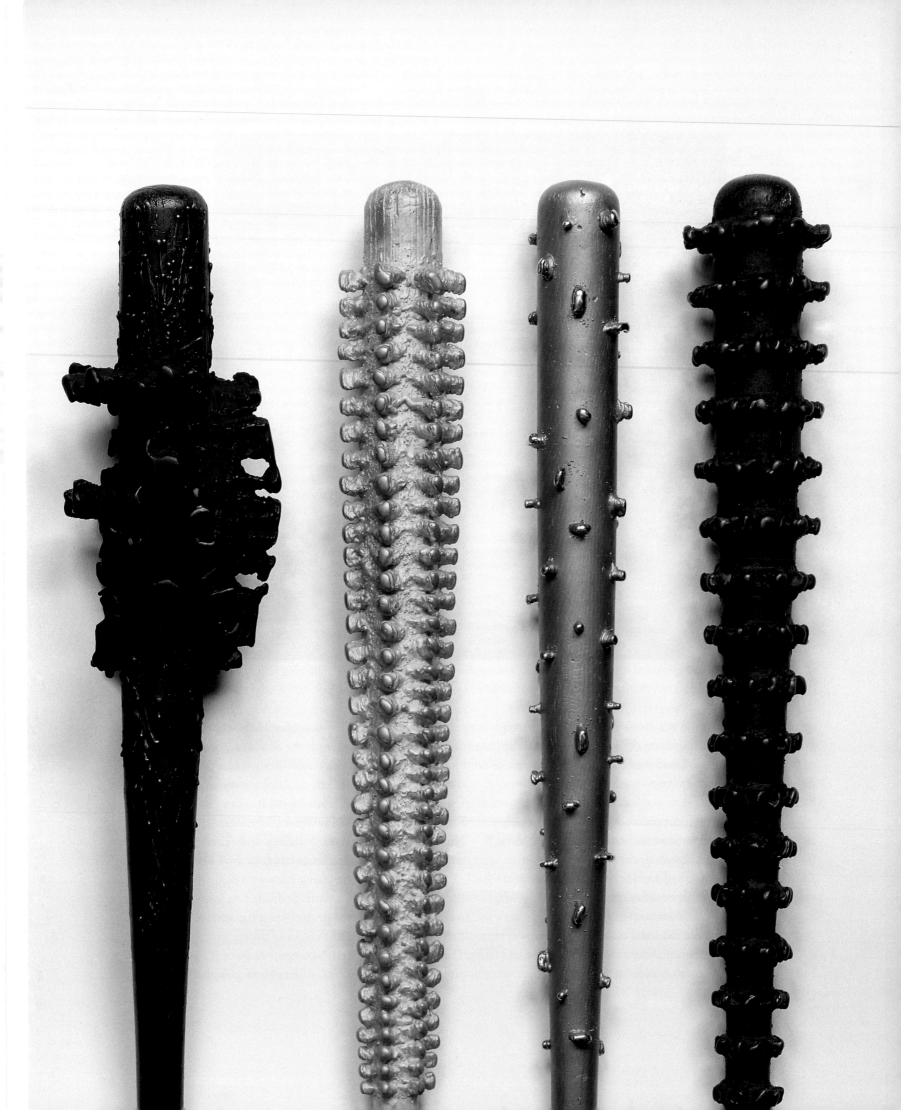

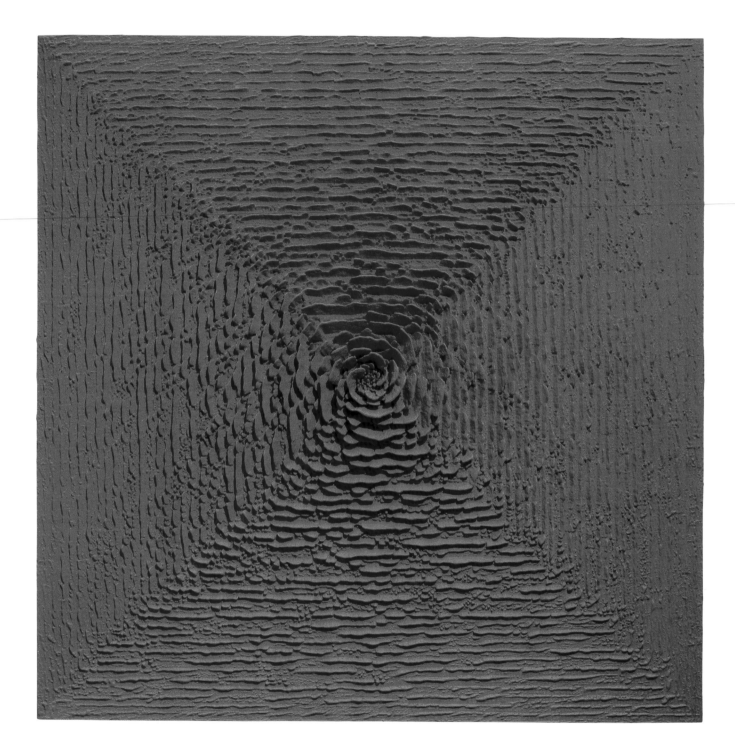

Excursions with Martin Kline

ELEANOR HEARTNEY 2011

One compelling aspect of Martin Kline's varied and complex work is the dialectic forged of Minimalism and expressive abstraction. His paintings import some of the vocabulary of Minimalism—including components such as seriality, the use of monochrome and the reduction of forms to simple geometric shapes. But he eschews the impersonal connotations of that movement for an expressive aesthetic that draws on ancient architecture, non-Western craft traditions and natural growth patterns. In place of Minimalism's literal materialism, his work reflects a spirituality that is equal parts American transcendentalism and Asian meditation. His work reconnects to an earlier vision of painterly abstraction that seeks out the deeper currents hidden beneath the ever-changing flux of visual experience. The result, in Kline's work, is a fruitful melding of apparent opposites. He seeks reduction, not to eliminate nature and metaphor, but rather to emphasize their expression. He references the visible world, not through illusion or representation, but by creating works that illuminate the processes of nature rather than depicting specific images.

While they differ widely in appearance, Kline's works are united by his interest in art's ability to reveal essences and reanimate our sense of beauty. Exploring processes that put a premium on craft and transparency, the finished works provide a unique aesthetic experience in form and color.

Kline's rich, multi-layered paintings are created by the application of strokes and daubs of colored encaustic to canvas or board. His use of encaustic involves the successive buildup of layers of pigmented wax, which has been heated until it becomes liquid and is then applied with a loaded paintbrush in various ways. With their raised surfaces and varied textures, these works share the characteristics of both painting and sculpture in striking equilibrium.

Kline uses the ancient technique of encaustic in fresh new ways. Take, for instance, the dome paintings. Their immediate connection is with ancient iconic forms and non-Western architecture, in particular vaults, domes, lingams, arches and arcades. But there also is a reference taken from Western modernism. Kline notes that one inspiration for this series came from Charles Demuth's 1927, *My Egypt*, a crisp precisionist masterpiece that endows a Midwestern grain elevator with the severe monumentality of the ancient temple at Karnak. Despite the title, there is no evidence that Demuth ever traveled to Egypt; instead it suggests that the artist's imagination can transcend ordinary time and space.

Similarly, Kline pays homage to imaginary journeys with works like *My India, Istanbul, Sofia* and *Babylon*. Like Demuth's monumental grain silos, Kline's structures derive less from actual travel than from the way that art can conjure a sense of place out of light, color, form and atmosphere. As the titles suggest, these works allude to far off locales. Yet they are as far as it is possible to be from tourist snapshots or travelogue illustrations. Drawn from Kline's interest in ancient cultures, these paintings present legendary cities as capitals of the imagination which stem from actual travel experiences as well as the mind's-eye invention of places of lands he is drawn to but has yet to visit. They conjure their subjects by adopting the opulent, jewel-like hues of Indian, Native American and Islamic architecture and crafts. These vaulted images are built up of chains of encaustic dots that explode with color as they cascade down the rounded forms like strings of beads. Some are touched with silver and gold, while others emulate the turquoise of Native American

Eros, 2010
encaustic on panel
48 x 48 x 4 inches (121.9 x 121.9 x 10.2 cm)
Dave and Pat Gibbons, New York, NY

beadwork and Iznik tiles or the deep indigo of the sixth chakra of Hinduism that is associated with intuition and spiritual knowledge. Kline extends this idea in a series of stripe paintings, in which bands of color are culled from their architecture and expanded upon. These works take a format associated with minimal and geometric abstraction and enrich it with allusions to textiles and weaving. Their brilliant colors and broken patterns once again suggest exotic locales where the world is suffused with light and color.

The blossom paintings are each characterized by the accumulation of encaustic paint built up from its low rise perimeter to a dramatic three dimensional center. Rows of horizontal and vertical marks echo the panel's shape, narrowing in toward a central core in a manner that brings to mind the early geometric and concentric square canvases of Frank Stella. Others evoke the target format associated with Jasper Johns and Kenneth Noland. These circles within squares, however, radiate outward or inward in sculptural relief.

These formalist references coexist with Kline's constant preoccupation with craft and nature. This is evident from the way the encaustic marks seem to grow like petals from the central core. You can sense the analogy to flowers, but also to crystals which grow through accretion. Often presented

singularly in monochrome paintings, these vividly colored square circles also recall the decorative traditions of India, Turkey and Asia. Martin Kline's explosive shades of blue, yellow and orange have multiple associations drawn from the realms of nature and culture. They contain echoes of the coruscating palette of such modernist masters as Yves Klein, Ellsworth Kelly and Barnett Newman, the pure hues of the Indian subcontinent and the sometimes almost preposterously brilliant colors of field and forest.

In all these works, Kline's working methods underscore the importance of process. The buildup of marks on the surface is slow and repetitive, requiring the artist to focus closely on the present moment. For the viewer, the complex pattern and raised surfaces mandate an analogous slowing down of time. One must look quietly and closely, and walk around these works, to allow the subtlety of texture to manifest itself in raking light. Such effects join artist and viewers in a meditative experience.

Delighting the eye, while encouraging us to look more deeply into ourselves, the work of Martin Kline injects new energy into the modernist tradition of abstraction. Connecting his art with nature, craft and spiritual meditation, he removes it from the sterility of purely reductive form, to breathe with the fullness of life.

Babylon (Small World), 2009
encaustic on panel
96 x 48 x 4 inches
(243.8 x 121.9 x 10.2 cm)

Ode to India, 2010
encaustic on panel
48 x 24 x 2⅜ inches
(121.9 x 61 x 6 cm)

Martin Kline

1961 Born in Norwalk, Ohio
Lives and works in Rhinebeck, New York
and New York City

EDUCATION

1983 Bachelor of Fine Arts, Ohio University, Athens, Ohio

SOLO EXHIBITIONS

2012 New Britain, Connecticut, New Britain Museum of
American Art, *Martin Kline: Romantic Nature*

2011 Houston, Meredith Long & Co., *Excursions with
Martin Kline*

Geneva, Gowen Contemporary, *Abstraction Rooted into
the World*

2009 Houston, Meredith Long & Co., *Nature into Structure*

2008 New York, Jason McCoy Inc., *Monochrome*

2007 Milwaukee, Haggerty Museum of Art, *Martin Kline:
Nature and Culture*

2006 New York, Jason McCoy Inc., *Made in Japan*

2005 New York, Jason McCoy Inc., *Truth Awakens as Fiction:
The Art of Martin Kline*

Copenhagen, Jason McCoy Inc., *Copenhagen Suite:
New Oilstick Paintings*

2004 New York, Jason McCoy Inc., *Stainless Steel Painting*

2002 New York, Marlborough Chelsea, *Painting Sculpture*

2000 New York, Marlborough Gallery*, New Works*

1996 New York, 65 Thompson Street, Gagosian Gallery,
Grids

Columbus, Ohio, Allez les Filles Gallery,
Martin Kline

1995 Zurich, ACP Gallerie, *Large Watercolors*

1994 New York, Stephen Mazoh, *Yuccas*

1993 Zurich, ACP Gallerie, *17 Drawings*

1992 New York, Stephen Mazoh, *Recent Drawings*

1985 Portland, Oregon, Information Technology
Institute, *Drawings*

1984 Portland, Oregon, Sumus Gallery, *Egyptian Themes*

1983 Athens, Ohio, Small Space Gallery, *Line Drawings*

GROUP EXHIBITIONS

2011 Cambridge, Harvard University Art Museums, Fogg
Museum, *The Western Tradition: Art Since the Renaissance*

New York, Marlborough Chelsea, *Powders,
a Phial and a Paper Book*

Mexico City, Isabel la Católica, *Piel/Skin*

2010 New York, Lehmann Maupin, *Painting and Sculpture at
Lehmann Maupin*

New York, Jason McCoy Inc., *I am Nature*

West Palm Beach, Eaton Fine Art, Inc., *Anti Icon*

2009 Salt Point, New York, Chambers Fine Art, *Art and
Rocks: Nature Found and Made*

2007 New York, Paula Cooper Gallery, *Grids: Carl Andre,
Jennifer Bartlett, Hans Hacke, Martin Kline, Sherrie Levine,
Sol LeWitt, Atsuko Tanaka, John Trembly, Dan Walsh,
Jackie Winsor*

2006 New York, Denise Bibro Fine Art, *Head Over Hand*

2005 New Paltz, SUNY, Samuel Dorsky Museum of Art,
Encaustic Works 2005

New York, Jason McCoy Inc., *Summer Exhibition:
Gallery Artists*

2004 Madrid, Museo Nacional Centro de Arte Reina Sofía,
Los Monocromos

Cambridge, Harvard University Art Museums, Fogg
Museum, *The Western Tradition: Art Since the Renaissance*

2003 New York, The Metropolitan Museum of Art, *Recent
Acquisitions: Works on Paper*

Cleveland, Cleveland Museum of Art, *Drawing Modern:
Works from the Agnes Gund Collection*

Houston, Museum of Fine Arts Houston, *Process and
Possibility: Contemporary Drawing in the Museum of Fine
Arts Collection*

New York, Marlborough Chelsea, *Group Exhibition*

Atlanta, Marcia Wood Gallery, *Encaustic Now/Series 2*

Chicago, Flatfile Contemporary, *Inaugural Exhibition*

Chautauqua, New York, Chautauqua Center for Visual Art, *Al Held, Martin Kline, Kim Anno: Watercolors*

2002 New London, Connecticut College, Cummings Art Center, *Encaustic Painting*

New York, Marlborough Chelsea, *Sculpture: Gallery Artists*

New York, Paul Rodgers 9w Gallery, *Mono-Chrome*

New York, Chambers Fine Art, *Rocks and Art: Nature Found and Made*

2001 Glens Falls, New York, The Hyde Collection Art Museum, SUNY College at Fredonia, New York; Michael C. Rockefeller Arts Center Gallery, Youngstown, Ohio; Butler Institute of American Art, Wayne, New Jersey; William Patterson University, Ben Shahn Gallery; University of Alabama, Tuscaloosa, Sarah Moody Gallery of Art, *Watercolor: In The Abstract*

New York, Marlborough Gallery, *Summer Exhibition: Gallery Artists*

New York, Gagosian Gallery (Chelsea), *Art 2000*

New York, Matthew Marks Gallery, *Drawings and Photographs*

1999 Montclair, The Montclair Art Museum, and Knoxville Museum of Art, *Waxing Poetic: Encaustic Art in America*

New York, Marlborough Gallery, *Summer Exhibition: Gallery Artists*

1998 Annandale-on-Hudson, Bard College, *Trace*

New York, James Graham & Sons, *Drawings*

New York, Jason McCoy Inc., *Summer Group Show*

1997 New York, Robert Steele Gallery, Union, New Jersey, James Howe Fine Arts Gallery of Kean University, *Intimate Universe (Revisited)*

New York, Elizabeth Harris Gallery, *Purely Painting*

1996 Bad Ragaz, Switzerland, Grand Hotels Resort, *Ornamente und Strukturen*

1995 Kornwestheim, Germany, Galerie der Stadt Kornwestheim, *Ornamentale Tendenzen: Martin Kline, Claude Sandos, Susanna Taras*

1994 Portland, Butters Gallery, *October Group Show*

1993 New York, Leo Castelli Gallery, *Drawings, 30th Anniversary Exhibition*

Venice, Peggy Guggenheim Collection, and New York, Guggenheim Museum SoHo, *Drawing the Line Against AIDS*

Paramus, Bergen Museum of Art and Science, *A Moment Becomes Eternity: Flowers as Image*

1992 New York, Metro Pictures Gallery, *Freedom of Expression '92*

1991 New York, Lorence Monk Gallery, *Drawings*

New York, Michael Walls Gallery, *Entr'Acte*

1990 New York, Michael Walls Gallery, *The Summer Exhibition 1990: Thirty Artists*

1987-89 Sarasota, Jack Voorhies Gallery, *Group Exhibitions*

1986 Pocatello, Idaho State University, *Big Sky Biennial IV*

Portland, Oregon, *Art in the Mayor's Office*

Coos Bay, Oregon, Coos Art Museum, *Gary Forner, Martin Kline, Nan Yragui*

1985 Stockton, California, *Stockton National Print and Drawing Exhibition*

Salem, Oregon State Fair, *All Oregon Art Annual*

Portland, Portland Art Museum, and Coos Art Museum, *Oregon Biennial*

Condon, Oregon, *Summit Spring's Art Slate '85*

1984 Portland Art Association, *Gallery Artists*

Salem, Oregon State Fair, *All Oregon Art Annual*

BIBLIOGRAPHY

2012 Price, Marshall N. Hudson Hills Press, "Natural Phenomenon," *Martin Kline: Romantic Nature,* Manchester

2011 Buhmann, Stephanie. "Die Verbindung der Abstrakten Kunst mit der Natur," *Art Collector,* Basel, August

Britt, Douglas. *Houston Chronicle,* Houston, May 24th

Dupree, Michael. "Mysterious Skin," *Paper City,* Houston, May

Heartney, Eleanor. Meredith Long & Co., *Excursions with Martin Kline,* Houston

Dumont, Etienne. "Les Cinq Meilleures Par Etienne Dumont," *La Tribune Genève,* Geneva, March

2010 Rankin, Lissa. *Encaustic Art, The Complete Guide to Creating Fine Art with Wax,* Watson-Guptill, New York

Rose, Barbara. Eaton Fine Art, *Anti Icon,* West Palm Beach

2009 Britt, Douglas. "Martin Kline," *Houston Chronicle,* Houston, March 11

Greene, Alison De Lima. Meredith Long & Co., *Nature into Structure,* Houston

Kline, Martin. "A Few Notes About Scholars Rocks," Chambers Fine Art, *Art and Rocks: Nature Found and Made,* Salt Point, New York

Tancock, John. "Art and Rocks," Chambers Fine Art, *Art and Rocks: Nature Found and Made,* Salt Point, New York

2008 Eshoo, Amy. ed., *560 Broadway; A New York Drawing Collection at Work, 1991-2006,* New Haven and London: Yale University Press

Rosenthal, Nan. Jason McCoy, Inc., *Monochrome,* New York

2007 Carter, Curtis L. Haggerty Museum of Art, Marquette University, *Martin Kline: Nature and Culture,* Milwaukee

Schumacher, Mary Louise. "Kline at the Haggerty," *Milwaukee Journal Sentinel,* Milwaukee, April 7

Wei, Lilly. "Martin Kline: Made in Japan," *Artnews,* February

2006 Kline, Martin. Jason McCoy Inc., *Made in Japan,* New York

"Made in Japan," *Asian Art News,* November/December

Rose, Barbara. "A New Iconography for Abstract Art," *Art & Antiques,* December

2005 Glueck, Grace. "Martin Kline: Truth Awakens as Fiction," *The New York Times,* November 25

Ratcliff, Carter. Jason McCoy Inc., *Truth Awakens as Fiction: The Art of Martin Kline,* New York

2004 Leffingwell, Edward. "Martin Kline," *Art in America,* June

van Zuylen, Marina. Jason McCoy Inc., *Oilstick Paintings,* New York

Foster, Carter. The Cleveland Museum of Art, *Drawing Modern: Works from the Agnes Gund Collection*

2003 Halasz, Piri. "Technique and Ambition," *NY Arts,* January

Hall, William. "From China to Chelsea, Chambers Fine Art," *Chinese Art News,* Taipei, September

2002 Ho, Christopher K., "Mono-Chrome," *Modern Painters,* Autumn

"Hot Wax," Cummings Art Center, Connecticut College, New London

Norden, Linda. Marlborough Chelsea, *Painting Sculpture,* New York

Reichek, Elaine. "Stitch and Pixel," *Tate International Arts and Culture,* London, September/October

Zhou, Liben. "Transcending Past and Present, East and West: Chambers Fine Art Arrives in New York with the Spirit of the East," *Art and Collection,* Taipei, March

Shulman, Ken. "Thorns and All," *Art & Antiques,* March

2001 Mattera, Joanne. *The Art of Encaustic Painting, Contemporary Expression in the Ancient Medium of Pigmented Wax,* Watson-Guptill, New York

Watercolor in the Abstract, The Hyde Collection, Glens Falls, New York

Scogin, Hugh T. Jr. Chambers Fine Art, *Rocks and Art, Nature Found and Made,* New York

2000 Everett, Deborah. "Martin Kline," *NY Arts: International Edition,* vol. 5, no. 2

Rose, Barbara. Marlborough Gallery, *New Works, A Conversation with Barbara Rose,* New York

1996 Heartney, Eleanor. "Martin Kline at 65 Thompson," *Art in America,* December

Rose, Barbara. 65 Thompson Street, *Life Enhancing Art,* New York

1995 Kraubig, Dr. Jens. Galerie der Stadt Kornwestheim, *Ornamentale Tendenzen,* Kornwestheim, Germany

1994 Geldzahler, Henry. Stephen Mazoh, Inc., *Yuccas,* New York

1993 Peggy Guggenheim Collection, Venice and Guggenheim Museum SOHO, New York, *Drawing the Line Against AIDS*

COLLECTIONS

Albertina, Vienna, Austria
Atlantic Pacific Fellowship, Miyakonojo, Japan
Brooklyn Museum, Brooklyn, NY
The Cleveland Museum of Art, Cleveland, OH
Harvard University Art Museums, Fogg Museum, Cambridge, MA
High Museum of Art, Atlanta, GA
Kemper Museum of Contemporary Art, Kansas City, MO
Kennedy Museum, Ohio University, Athens, OH
The Metropolitan Museum of Art, New York, NY
The Museum of Fine Arts Houston, Houston, TX
New Britain Museum of American Art, New Britain, CT
Portland Art Museum, Portland, OR
Princeton University Art Museum, Princeton, NJ
Triton Foundation, Belgium
Whitney Museum of American Art, New York, NY
Yale University Art Gallery, New Haven, CT

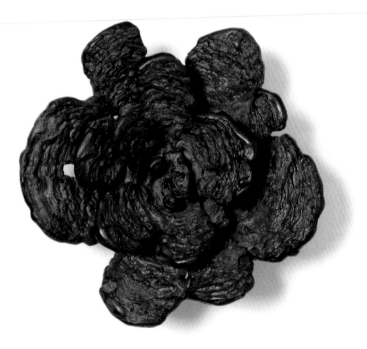